A–Z

OF

SOHO AND FITZROVIA

PLACES - PEOPLE - HISTORY

Johnny Homer

AMBERLEY

Dedicated to Johnny Homer
11 September 1964–9 July 2021
A husband and father beyond compare.
Love always,
Lydia and Harriet
XxX

First published 2021

Amberley Publishing
The Hill, Stroud, Gloucestershire, GL5 4EP
www.amberley-books.com

Copyright © Johnny Homer, 2021

The right of Johnny Homer to be identified as
the Author of this work has been asserted in
accordance with the Copyrights, Designs and
Patents Act 1988.

ISBN 978 1 4456 9475 7 (print)
ISBN 978 1 4456 9476 4 (ebook)

British Library Cataloguing in Publication Data.
A catalogue record for this book is available
from the British Library.

Typesetting by SJmagic DESIGN SERVICES,
India. Printed in Great Britain.

Contents

Introduction

Soho isn't what it used to be, but then it never was.

Jeffrey Bernard

Soho and Fitzrovia are two of London's most vibrant districts, separated physically by Oxford Street but linked by a shared history of bohemianism, radicalism and cosmopolitanism. Until the 1940s, when the term 'Fitzrovia' was first coined, this area to the north of Oxford Street was widely known as North Soho. The two areas have always been linked, in spirit if not geography.

My first foray into this part of London's wild West End would have been in my early teens, for I was obsessed with rock and pop music and both Fitzrovia and Soho boasted many great records shops, all now sadly gone.

Below and opposite: Duck Lane and Bradley's Bar, Hanway Street. Despite change, Soho and Fitzrovia retain much of their charm.

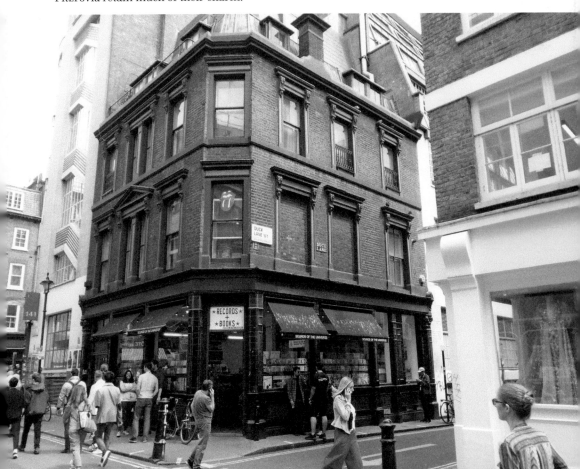

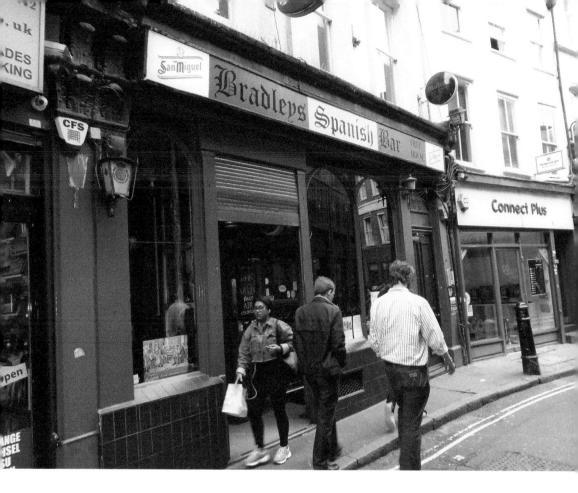

Later I would visit Soho to see live music at venues such as the Marquee and the WAG Club, Break for the Border and occasionally the Astoria. Later still my work as a journalist would bring me to the area, sometimes to watch films in one of Soho's many preview cinemas and sometimes to interview the latest 'pop sensation' at the offices of one of the many record companies then based in W1.

I later spent three highly enjoyable years working in an office in Carnaby Street. I look back on that time with particular fondness, for it was during this period that Soho really got under my skin. I have been addicted to the place ever since.

Fitzrovia, meanwhile, is a wonderfully moody place. Walk around its streets on a Saturday afternoon and the place will be sparsely populated with the majority of businesses closed. It is quite a contrast to the shopping Mecca of Oxford Street just yards away. As with Soho, this is one of my favourite parts of London.

I have enjoyed writing this book tremendously. It has revealed what a fascinating history these two areas of London have while also giving me the opportunity to revisit some old haunts.

These have always been areas of change, but in recent years that change has been more dramatic and more rapid than ever, especially in Soho, where not only is the area's appearance changing, but the feel of the place is too. Also, the damage that the Crossrail project has inflicted on the area is nothing short of disgraceful. Every time

I walk along Charing Cross Road I am left both angry and sad at the seemingly casual demolition of the lovely old Astoria, gone the way of the ball and chain in the name of so-called progress.

This book, then, aims to be a slightly different guide to Soho and Fitzrovia, and I make no apologies for any quirk or strangeness you might encounter along the way. Nor do I make any apology for the number of pubs included, for some of London's best – and most interesting – pubs can be found here.

And while the future of these districts remains unclear, for the moment they remain two of London's great *quartiers*. There's still magic in the air if you know where to look.

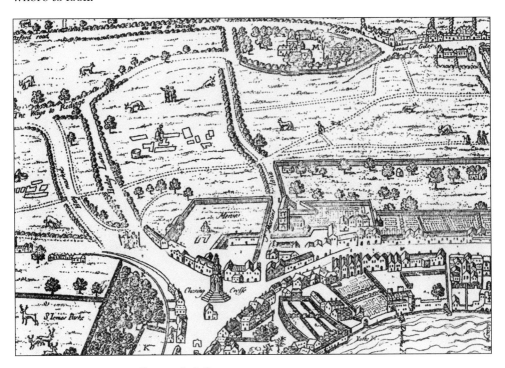

Soho in the late 1500s, still a rural idyll.

A

Algerian Coffee Store – Wake Up and Smell...

Located at No. 52 Old Compton Street, the Algerian Coffee Store, with its distinctive candy-striped shop awning and even more distinctive smell, is one of the area's few surviving old-style food and drink emporiums and has been trading here since 1887.

It was founded by Mr Hassan, a Belgian of Arab extraction, but has been in the hands of the Crocetta family since 1946. Marisa Crocetta, who currently manages the shop, is the third generation of her family to do so.

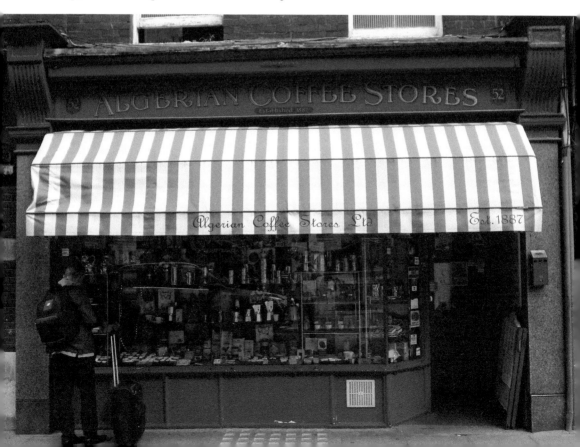

Left and previous page: The Algerian Coffee Store has been trading in Old Compton Street since 1887.

The shop fittings are distinctly old school with dark wooden shelving and an array of jars and bags of coffee on display. Available are around ninety different coffees from all over the world, most of them in the form of beans which can be ground to your personal requirement. They also stock more than 120 types of tea and a veritable treasure trove of equipment.

You can even get a shot of espresso to go, possibly the best you'll find in Soho.

All Saints', Margaret Street – You Can See the Spire from Primrose Hill

Simon Jenkins, in *England's Thousand Best Churches*, describes All Saints' as 'architecturally England's most celebrated Victorian church.' It's certainly a treat for the senses on several levels, and with a spire some 227 feet in height dominates Margaret Street, an otherwise dowdy thoroughfare unless you know what you're looking for. According to the church's own history, the spire can be 'clearly seen' from Primrose Hill, 'holding its own against a London skyline much more crowded today than it was in 1850'.

The foundation stone for today's church was laid in 1850 by Dr Edward Pusey. Pusey was a prominent figure in the Oxford Movement, a High Church group which eventually embraced a form of Anglo-Catholicism. The eighteenth-century Margaret

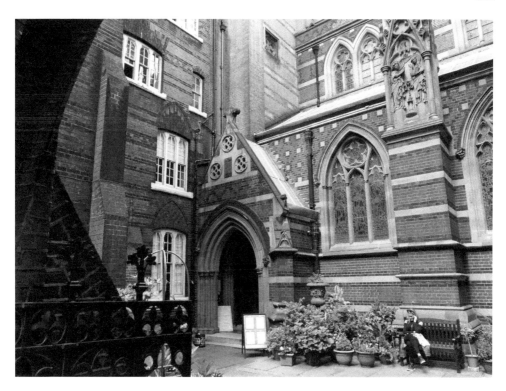

Above and right: All Saints' dates from the 1850s.

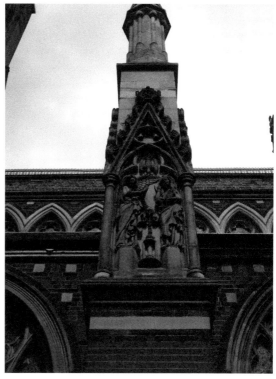

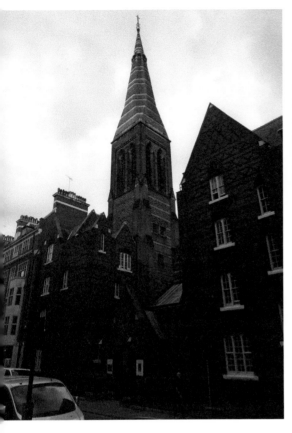

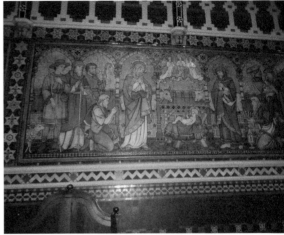

Above: Detail of painted tableau inside All Saints'.

Left: The spire is 227 feet tall and can be seen from Primrose Hill.

Chapel formerly occupied the site, when the congregation included William Ewart Gladstone, later to become Prime Minister, and William Butterfield, architect and a leading light of the Gothic Revival movement.

It was no coincidence, clearly, that Butterfield was assigned with building the 'model' church that is today's All Saints', the initial commission coming from Sir Alexander Beresford-Hope, Member of Parliament at the time for Maidstone, Kent. The project swallowed up some £70,000 of his own money, but the construction itself was a troubled affair and it wasn't consecrated until 1859, Bishop of London Dr Tait on hand to do the honours.

It is a remarkable building, externally and especially inside. This interior is large, spacious and ornately decorated. Of particular note are a series of painted tableau depicting the saints and also the Nativity, originally by the Scottish artist William Dyce and 'renewed' in 1906. Dyce was loosely associated with the Pre-Raphaelite movement, and here it shows.

All Saints' is Grade I listed and today, in addition to being a place of worship, offers a place of daytime refuge for many of the area's homeless.

B

Bar Italia – Iconic Coffee Bar, Immortalised by Pulp

Bar Italia in Frith Street is the last of Soho's great post-war coffee shops. It was started by the Polledri family in 1949 and they are still at the helm more than seventy years on.

Despite being historically known as London's French quarter, a growing Italian community started to inhabit Soho from the turn of the twentieth century onwards, reaching a peak in the interwar years.

The proliferation of restaurants in the area provided an abundance of kitchen and waiting work for this growing population, a population whose presence also goes some way to explaining the many delicatessens that once flourished in Soho.

Below left and below right: Bar Italia is a Soho institution.

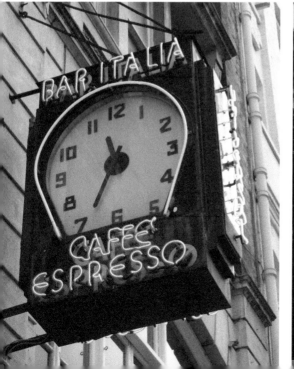
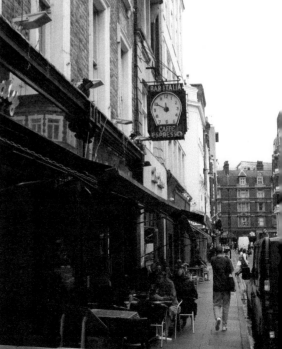

Above, below left and below right: Bar Italia's interior has changed little over the years.

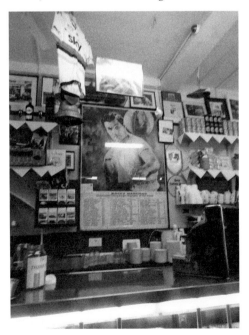

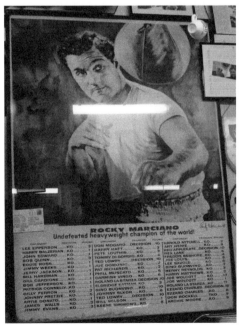

When Italy declared war on Britain on 10 June 1940, much of the male London Italian community were promptly interred, with many well-known Soho faces rounded-up by the authorities.

Four years after war ended, Lou and Caterina Polledri borrowed £50 from an ice delivery man of their acquaintance and set up Bar Italia.

In an age of gentrification, and despite the change that has ravaged much of Soho in recent years, Bar Italia has retained most of its original 1950s decor and fittings, and the famous portrait of boxer Rocky Marciano still glares down at customers from the wall behind the counter as it has done for many, many years. Apparently Lou and Caterina's son Nino was friends with the great American pugilist.

The coffee is pretty good too, and all of these things combine to make this an essential part of twenty-first-century Soho life. It can even claim to have been immortalised in song, namely the track 'Bar Italia' from Pulp's 1995 album *Different Class*.

Blake, William – Cockney Visionary and Son of Soho

Although poet, printmaker and painter William Blake struggled for recognition during his lifetime – and was largely ignored, particularly by his peers – he has subsequently come to be regarded as an important figure of the Romantic period. The writer Peter Ackroyd has described him as a 'Cockney visionary'.

Blake was born on 28 November 1757 at No. 28 Broad Street, his father's hosiery shop. Both of his parents were Dissenters and seem to have encouraged the young William to pursue artistic interests: in his teens a modest allowance from his father had enabled him to build up a collection of prints.

Broad Street is now Broadwick Street, one of Soho's main arteries, and the shop stood on what is today the corner of Broadwick Street and Marshall Street. Given the high regard in which Blake is now held, it seems hard to understand how this building was allowed to be demolished in 1966. Standing on part of the site today is William Blake House, a sixteen-storey tower block completed in 1966 and described by Pevsner as 'an excellent building'.

Apart from three years spent living in Sussex, Blake lived his whole life in London. He resided variously in Poland Street and spent a year or so living in Cirencester Place, today's Great Titchfield Street, a thoroughfare located deep in the heart of Fitzrovia. He also resided at houses in South Molton Street, Green Street (today's Orange Street, near Leicester Square) and, during one of the happiest and most productive periods of his life, across the Thames in Lambeth.

At the age of fourteen Blake attended drawing school and was then apprenticed to an engraver called James Basire, whose studio was in Great Queen Street, Covent Garden.

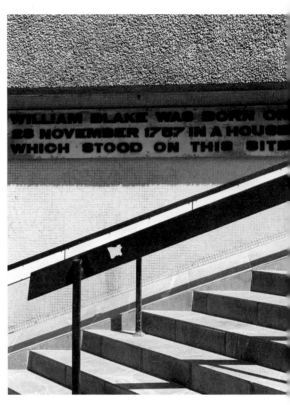

Above left: The house where William Blake was born, demolished in 1966. (London Metropolitan Archives – City of London)

Above right: Today a plaque (roughly) marks the spot. (Daniela Rosello)

Blake later studied at the Royal Academy, although only briefly for he had little time for Academy president Sir Joshua Reynolds.

Blake's early career was as a commercial engraver, but the urge to create his own work was strong even then. Blake married Catherine in 1782 and two years later, in partnership with James Parker, opened a print shop, at No. 27 Broad Street, next door to the house of his birth. This partnership was dissolved after little more than a year, Parker retaining the shop and Blake the printing press.

In 1789 Blake published *Songs of Innocence* and in 1794 *Songs of Experience*, collections containing his visionary poetry with text and illustrations engraved and hand coloured by Blake himself. He would also provide illustrations for other writers, notably John Milton.

Blake's poem *Jerusalem*, written in 1820, was set to music by Charles Parry in 1902 and has subsequently become the thing Blake is best known for.

Blake died on 12 August 1827. He and Catherine were then lodging in a house in Fountain Court, just off the Strand. He was buried in Bunhill Fields, the great nonconformist burial ground.

Berwick Street – Soho's Street Market

Berwick Street runs from Peter Street to Oxford Street and was named in honour of James FitzJames, the 1st Duke of Berwick and illegitimate son of James II. It was laid out between 1687 and 1703, although the street market for which it is best known today was not established until the 1770s and only officially recognised as a market in 1892.

Given the cosmopolitan nature of Soho, the market was known as a place to track down such exotic and elusive foodstuffs as aubergine, grapefruit, tomatoes (yes, tomatoes) and olive oil. Olives too. Today the market stretches as far as the junction with Broadwick Street, and like many old London markets is now largely comprised of street food vendors, although a few fruit and veg merchants remain to at least give a hint of the old Berwick Street.

Berwick Street can also boast a claim to rock and roll fame, for it was here that the cover shot for Oasis's 1995 album *(What's the Story) Morning Glory?* was taken. This was to prove their breakthrough long-player, somehow going on to sell more than 22 million copies despite, or perhaps because of, its simplistic selection of Beatles-like anthems and sixth-form poetry.

The front cover shows two men passing each other on the stretch of Berwick Street known for its many record shops. In the background can be seen a third man holding aloft an object. The man is Owen Morris, who produced the album, and the object he holds are the master tapes of the album.

Weinreb and Hibbert, in their *London Encyclopedia*, note 'several houses' that date from the 1730s, among them No. 48, which is Grade II listed by Historic England.

Elsewhere, the Green Man at No. 57 is one of the area's oldest surviving pubs and has stood here since 1738. The current building is of early nineteenth-century origins.

Another pub can be found at No. 22 Berwick Street, namely the Blue Posts. There has been a tavern on this site since at least the 1730s, originally known as the Three Blue Posts. This is one of the finest, if not the finest, surviving example of an old school Soho boozer.

Right and overleaf: Berwick Street, pictured in 1920, and today.

When the British film industry centred on nearby Wardour Street this was a popular watering hole for those who worked in it. Much of its clientele today work in the media.

Jessie Matthews, a major star of both film and stage from the 1920s through the post-war years, was born in Berwick Street in 1907, one of sixteen children. A plaque dedicated to her adorns the wall of today's Blue Post, which is described in 1963's *Survey of London* as 'neo-Georgian' with 'a few art nouveau details'.

C

Carnaby Street – Once the Epicentre of Swinging London

Until the late 1950s Carnaby Street was a rather anonymous Soho street consisting of a selection of small shops and businesses. By the mid-1960s it was one of the most famous addresses in the world, a place that alongside the King's Road in Chelsea had become globally associated with the phenomenon (or at least the perceived phenomenon) of swinging London.

Carnaby Street was laid out in the early 1680s when a local bricklayer named Richard Tyler secured a building lease for the area. The street takes its name from Karnaby House, which Tyler erected on the east side of the street in 1683. This was a rather grand affair designed to promote his development, and within a decade the

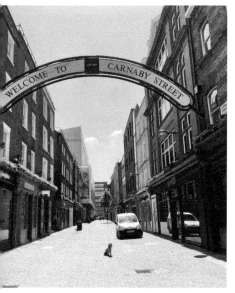
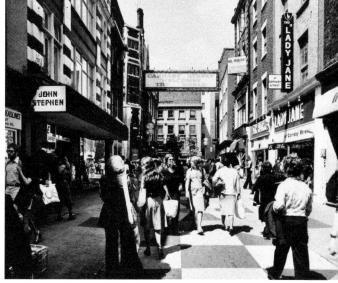

Above left and above right: Carnaby Street today and in 1975, shortly after its pedestrianisation. (Daniela Rosello) (London Metropolitan Archives – City of London)

immediate area was heavily built up. Much of the population during this development were French Huguenots.

The area was redeveloped from the 1720s onwards, and the Shakespeare's Head pub, which still stands in a later form on the corner of Fouberts Place and Great Marlborough Street, was established around 1735. The men behind this venture were John and Thomas Shakespeare, possibly descended from the Bard himself.

Carnaby Street's fortunes over the years seem to have ebbed and flowed rather. It was described in the 1930s by one local as 'one of the filthiest streets in Soho', but in the post-war years was known for its small and bespoke businesses, which included the famous tobacconist Inderwick's, founded by John Inderwick in 1797 and relocating to Carnaby Street from Wardour Street.

In the late 1950s a number of small 'rag trade' operations were based here, many supplying clothes to high-end Savile Row and other Mayfair operators. Working as an apprentice cutter at one of them was a young man called John Stephen, and aware that fashion was changing he struck out on his own. He opened a menswear shop called His Clothes, which started in Beak Street in 1960 before moving the short distance to Carnaby Street soon after. Other shops followed, slowly at first, but the pop and fashion explosion of the early 1960s unleashed a major cultural shift, and by 1964 Carnaby Street almost totally consisted of clothes shops, or 'boutiques' as they were more commonly called.

This was a place to see and be seen, a real and genuine scene for a while. Many a teenage pop fan could hang out in Carnaby Street on the off-chance of seeing a Kink or a Stone. Often they would.

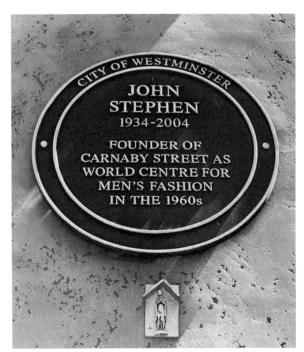

John Stephen was largely responsible for Carnaby Street's transformation.

By 1965, as tends to be the way with 'scenes', rents went up and big business and chain stores moved in. Carnaby Street, once the epitome of cool, had become little more than a tourist attraction. Which is why the Kinks' 1966 hit *Dedicated Follower of Fashion* is satire, not homage. When Westminster City Council pedestrianised the street in the early 1970s, it became even more of a stop-off point on the tourist trail.

Casanova – Lothario, Lawyer, Lottery Entrepreneur and Spy

In 1763 Giacomo Girolamo Casanova, simply Casanova as he is better known, arrived in London. Given his reputation as a great lover, and bearing in mind his seemingly insatiable appetite for sex, it comes as no surprise that based himself in Soho, an area which even in the eighteenth century had a reputation for salaciousness and sin.

Casanova's life was remarkable. He was born in Venice in 1725 and after graduating from university aged seventeen, with a degree in ecclesiastical law, he got into debt through gambling before embarking on a career first in the church and later in the military, neither of which he stuck at.

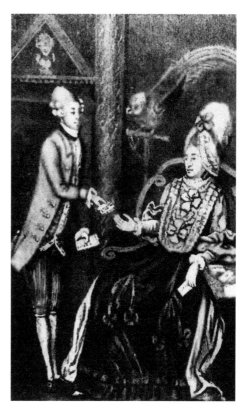

Theresa Cornelys – the apple of Casanova's eye?

Casanova would change his path in life with casual regularity. He also, from an early age, was attracted to women, and this is of course what history best knows him for. This pursuit of women would almost inevitably lead to trouble and was one of the main reasons why he spent so much of his life travelling from city to city and country to country, changing his identity several times along the way.

He arrived in London from Paris after falling out with the Marquise d'Urfe, an aristocrat who had supported him financially. They were also lovers. Casanova's aim while in London was to interest the English in the idea of a state lottery. He even managed to wangle himself an audience with George III, although the lottery scheme came to nothing.

During his time in Soho Casanova lived in Greek Street. Although history does not record exactly where in Greek Street, it was likely to be near Soho Square, for in Soho Square was Carlisle House and in Carlisle House was Theresa Cornelys.

Cornelys was an opera singer with a string of lovers left behind in her wake, including Casanova, with whom she'd had a daughter some years before their paths crossed again in London. Was Casanova in London to sell the idea of a lottery to the English? Or was he in London in pursuit of Cornelys?

Casanova's time in London was relatively short. After contracting venereal disease, he left the capital, living a nomadic existence for the rest of his days before passing away in Bohemia, today's Czech Republic, in 1798, aged seventy-three.

Cleveland Street – Scene of Victorian Scandal

Walking along Cleveland Street today it is hard to conceive that for a brief period during the summer of 1889 it was at the heart of a Victorian sex scandal that involved both the aristocracy and the Royal Family.

Cleveland Street itself was laid out between 1745–50 on land belonging to Charles Fitzroy, the Duke of Southampton. His father was Charles II and his mother the Duchess of Cleveland – hence the street name. It runs north from Goodge Street to its end at Euston Road and can boast an array of very interesting buildings, ranging from late Georgian terraces to 1960s modernism; The Post Office Tower looms large.

For many years it was dominated by the Cleveland Street Workhouse, which later became an annexe of the Middlesex Hospital. It was designed to cater for the poor and destitute of the parish of St Paul's, Covent Garden and parts of the building itself, which still stands, date from its 1788 construction.

It ceased to be a workhouse in the 1870s and was used as an asylum and infirmary before becoming an annexe of the nearby Middlesex Hospital, the main body of which dominated Cleveland Street at the Goodge Street end. The hospital was demolished in 2008 and replaced with a bland modern development, although the workhouse building was given Grade II listing in 2011.

A gay bordello was once
located in Cleveland Street.

The Cleveland Street scandal, as it became widely known, first emerged in July 1889, when police were called to the London Central Telegraph Office to investigate a number of thefts. When a fifteen-year-old telegraph boy named Charles Thomas Swinscow was searched police found fourteen shillings in his pocket, the equivalent to at least a month's wages. Questioned as a suspect in the theft case, Swinscow instead revealed that he had acquired the cash through working at a male brothel run by a man called Charles Hammond. It operated out of a house at No. 19 Cleveland Street.

It later transpired that several other telegraph boys also frequented the Cleveland Street brothel, and as enquiries progressed one of the boys, Henry Newlove, made the sensational claim that clients of the bordello included Henry Fitzroy, Earl of Euston no less, and Lord Arthur Somerset. Somerset was equerry to the Prince of Wales, who not surprisingly given his colourful sex life, is also believed to have visited the brothel.

As the authorities discovered the identities of some of the clients, a cover-up was put into operation, largely at the behest of Queen Victoria it appears, resulting in the silencing of witnesses and many of those involved being allowed to leave the country, some never to return.

The house was demolished in the 1890s as the Middlesex Hospital grew in size.

Coach and Horses – Soho's Most Famous Pub

While it is the French in Dean Street that most encapsulates the spirit of cosmopolitan, bohemian Soho, the Coach and Horses in Greek Street is without doubt the area's best-known pub.

This status seems to have been achieved by accident, because for many years this was a decent but unremarkable Soho watering hole. However, a combination of old school pub

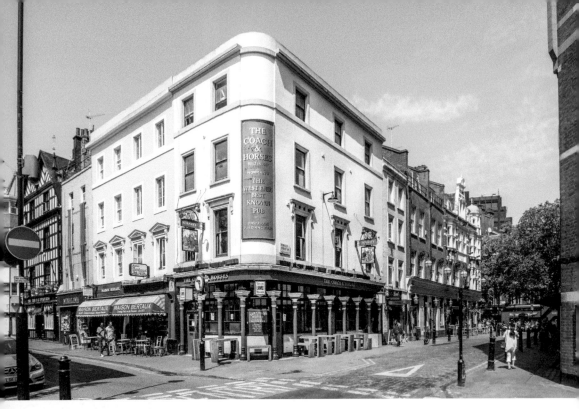

Above and left: The Coach and Horses is one of London's best-known pubs.

landlord – a genuine character – and a bunch of regulars who drank professionally – when they weren't working in the media – have given the 'Coach' a profile nationally (and internationally) that any Pubco press officer would sell their grandmother for.

There has been a tavern here since at least the 1720s, although the current building dates from 1847 and has been Grade II listed since 1978. Historic England note its 'distinctive pub frontage' which combines 'a series of later-C19 fluted cast-iron columns which stand proud of the bar room entrances'. The building had a makeover in 1889 and the wonderful interior you'll find today is the result of a refurbishment in the 1930s which gave the Coach the feel of an interwar pub.

In 1943 sixteen-year-old Norman Balon arrived at the pub. His father had taken over as landlord, a role which would pass to his son, and it was under Norman's stewardship that the pub became one of London's most famous. Balon did not suffer fools gladly – or any other way – and his offhand way with tiresome customers, often using language that would make a docker blush, earned him the title of 'London's rudest landlord'. Balon's 1991 memoir was titled *You're Barred, You Bastards*.

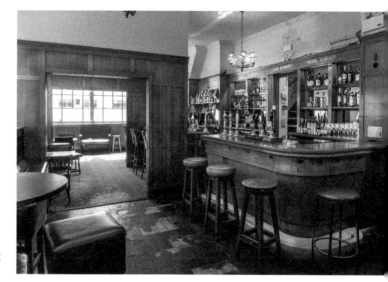

Right and below: The pub's interior has many surviving interwar features.

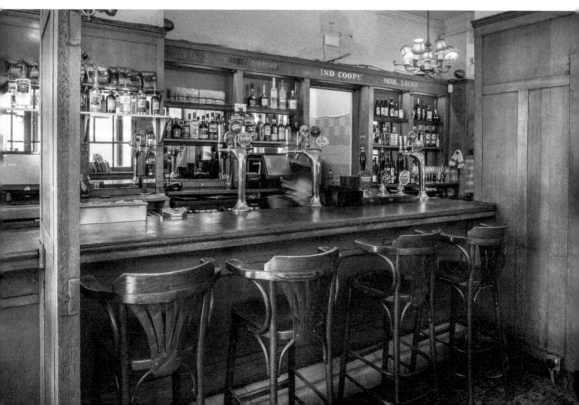

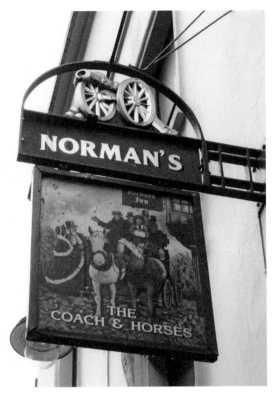

The pub is still known to some as 'Norman's'.

Balon's intolerance also stretched to the local gangster community, and he is celebrated for standing up to them in the face of much intimidation.

Adding to the pub's general down-at-heel ambience were the customers, among them the cartoonist Michael Heath and the journalist Jeffrey Bernard. It was through Bernard's weekly Low Life *Spectator* column that the pub really acquired its reputation in the media.

Balon retired from the pub in 2006, although his name still adorns the sign. Bernard died in 1997.

It is worth noting that this isn't the only Coach and Horses pub in Soho, for there is another at Great Marlborough Street, which can trace its history back to 1739, and another on the corner of Old Compton Street and Charing Cross Road, which has been around since at least 1731 and might just be the oldest of the three.

D

Dog and Duck – Orwell Supped Here

The Dog and Duck, standing proudly on the corner of Bateman Street and Frith Street, is one of perhaps half a dozen or so pubs in Fitzrovia and Soho truly deserving of the overused epithet iconic.

There's been a tavern of one sort or another on this site since at least 1734 – built on land once occupied by part of the Duke of Monmouth's grand townhouse – but the current

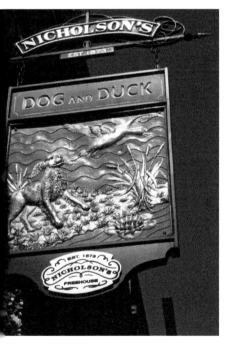

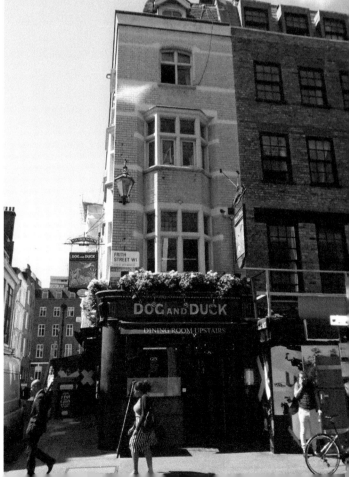

Above and right: The Dog and Duck is an iconic Soho pub.

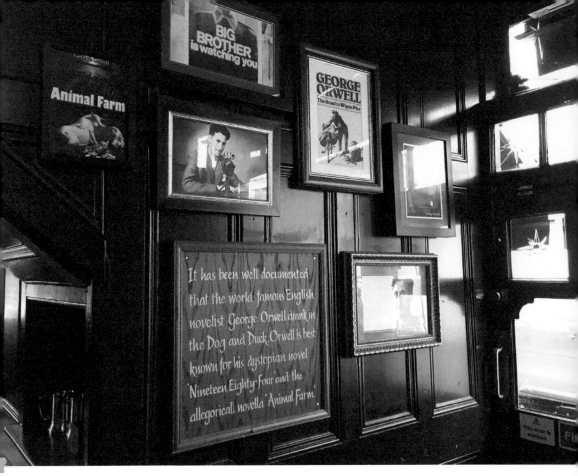

It has been well documented that the world famous English novelist George Orwell drank in the Dog and Duck. Orwell is best known for his dystopian novel 'Nineteen Eighty-Four' and the allegorical novella 'Animal Farm'.

George Orwell was a regular.

rather handsome structure dates from an 1897 rebuild, the work of fabled pub architect Francis Chambers who oversaw the project for the Cannon Brewery, once of Clerkenwell.

It is an intimate pub, nearly always busy, and can boast some exquisite original tiling, cut glass and mirrors. The ground-floor bar back is a thing of some beauty. The pub, not surprisingly, has been Grade II listed since 1989 and is included in CAMRA's *National Inventory of Historic Pub Interiors*.

Madonna once popped by for a light ale, apparently, although a more worthy claim to fame is that it was here where George Orwell raised a celebratory glass of mild upon discovering that *Animal Farm* had been chosen in 1946 for circulation by the American Book of the Month Club.

Drinking Clubs – Somewhere to Go When the Pub Shuts

We take all-day pub opening hours rather for granted today, but it wasn't always quite such a relaxed affair. In 1914, just days after the start of the First World War, Asquith's

Liberal government rushed through the Defence of the Realm Act, a far-reaching piece of legislation that included a drastic reduction in pub opening hours.

This included the introduction of afternoon closing for public houses, effectively splitting the drinking day into two sessions. Initially these new opening hours were noon–3 p.m., and then 6.30–9.30 p.m. Although relaxed and broadened slightly in future years, these draconian hours remained in place until the Licensing Act of 1988.

These restrictions on drinking time were felt perhaps more than most by the denizens of Fitzrovia and Soho, and so what developed were a number of 'members only' clubs that could circumnavigate the pub drinking hours and offer said members the opportunity to, effectively, drink all day.

At No. 69 Dean Street could be found the Gargoyle, which had been established here in 1925, the brainchild of a minor aristocrat called David Tennant. Matisse was responsible for some of the interior artwork, which was sadly later sold. In later years the same site hosted one of London's first comedy clubs, the New Romantic hang-out Gossip's and The Batcave, a Goth nightclub.

The Mandrake, opposite the Colony and situated in a basement which was connected to the Gargoyle, was originally set up for chess enthusiasts, soon attracting a wider clientele drawn to its all-day and late opening hours. It once proclaimed itself in a newspaper ad as 'London's only Bohemian rendezvous'.

The most famous of these clubs, however, was the Colony Room at No. 41 Dean Street, 'a small and shabby room with a telephone and lavatory at the back', according to Daniel Farson. It was founded in late 1948 by the formidable Muriel Belcher. Before the war she had run a club called the Music Box in Leicester Place, but it was at the Colony that she would become the stuff of Soho legend, overseeing a motley and diverse group of regulars from her stool at the bar.

These regulars might at any one time include the writer Colin MacInnes (author of *Absolute Beginners*), the artist Lucian Freud, journalist Jeffrey Bernard, the musician George Melly and the painter Francis Bacon, to name just a few.

When Belcher died in 1979 the equally irascible Ian Board took her place. He was followed by Michael Wojas in 1994, but the club finally closed, amid some acrimony, in 2008.

With today's more relaxed pub hours, twenty-first-century Soho membership clubs, such as the Groucho in Frith Street and the House of St Barnabas in Greek Street, are much, much more than just places to drink.

Eastcastle Street – Name-checked in *The Ladykillers*

Running west from Newman Street to Great Titchfield Street, Eastcastle Street was laid out throughout the 1760s and was originally known as Castle Street. On first inspection it looks a fairly unremarkable thoroughfare, but a closer look reveals some delightful historical nuggets.

At No. 13 on the corner with Wells Street is the Champion, a pub with a unique character all of its own. Built in the 1860s, and having undergone a major refurbishment in the 1950s, it has enjoyed Grade II listing since 1970.

It is noteworthy for its beautiful stained-glass windows. These are dedicated to a selection of noted Victorians and Edwardians, all of them 'champions' of sorts. Those featured include explorer David Livingstone (1813–73), cricketing legend WG Grace (1848–1915), pugilist Bob Fitzsimmons (1862–1917) and cross-channel swimmer Captain Matthew Webb (1848–83), among many others.

The windows were installed in 1989, the work of artist Ann Sotheran.

Below left and below right: The Champion, Eastcastle Street.

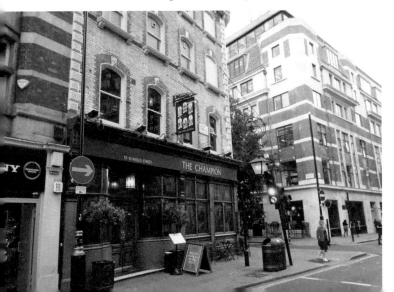

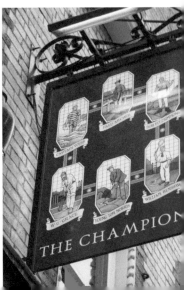

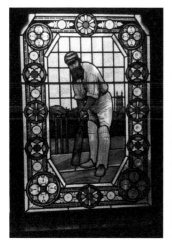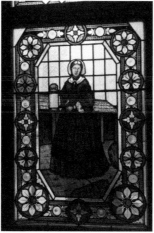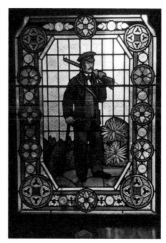

Left to right: WG Grace, Florence Nightingale and David Livingstone.

At No. 30 is the Welsh Baptist Chapel, which was built in 1888 to cater for the growing Welsh community then settling in London. The building was expanded soon after completion to cope with a growing congregation. David Lloyd George, Prime Minister between 1916 and 1922, attended occasionally.

The building has been Grade II listed since 1987, and is one of the few places of worship in the capital where services are conducted in Welsh.

For people of a certain age, however, Eastcastle Street is perhaps best known as the location for an audacious armed robbery that took place on 21 May 1952.

The robbery had clearly been very well planned, and saw two cars sandwich-in a post office van, coshing the unfortunate post office workers before driving off in the stolen van. The van was discovered abandoned a mile or so away from the scene of the crime. Missing were eighteen of the thirty-one mailbags it had been carrying.

In total some £287,000 was stolen, more than £8 million in today's money. At the time it was the largest British post-war robbery, and although the money was never recovered and no one was ever convicted, it has become accepted fact down the years that the London gangster Billy Hill, a well-known 'face' in Soho, was the man behind the crime.

'The Eastcastle Street job' was referenced a few years later in the classic 1955 Ealing comedy *The Ladykillers*, proof that the robbery had well and truly wormed its way into the greater public consciousness.

L'Escargot – One of London's First French Restaurants

In 1896 Georges Gaudin started a restaurant in Greek Street that he called Le Bienvenue. Soho was essentially Little France back then, and had been for some time, so the claim

made in some quarters that Gaudin's eatery was London's 'first' French restaurant should be taken with a pinch of salt. After all, what would eventually become Kettner's was operating from 1867.

Nevertheless, Gaudin's establishment soon became well known for its speciality, namely snails, and was probably the first restaurant in England to serve this particular delicacy.

In 1927 the restaurant shifted location along Greek Street, moving into No. 48 at what had previously been a rather grand townhouse. The building itself dates from 1742 and has been Grade II listed since 1958. It was for a time the London residence of the Duke of Portland.

The extra room afforded in these new premises enabled Gaudin to establish his own snail farm in the basement, which for a while was the talk of London gastronomic circles. In between shifts kitchen staff would race snails for money.

This move of location also saw a change of name, to L'Escargot Bienvenue to reflect the restaurant's signature dish. A bust of Gaudin, which has been in situ here for many, many years, bears the motto 'slow but sure' and the restaurant has long been regarded as one of the capital's best, its exterior neon sign one of Soho's most familiar sights.

When Gaudin retired in 1970 his son Alex took his place. In the 1980s it was taken over by the restauranteur Nick Lander and his wife, the wine expert Jancis Robinson. They installed Elena Salvoni to handle front of house duties. Something of a Soho legend in her own right, she put her stamp on L'Escargot for the next decade. So much so that the restaurant was often referred to as 'Elena's Place'.

The restaurant was refurbished in 1998, with the partnership of 'superchef' Marco Pierre White and Jimmy Lahoud at the helm, and changed hands again in 2014. The menu remains very heavily influenced by classic French cooking. They still serve snails.

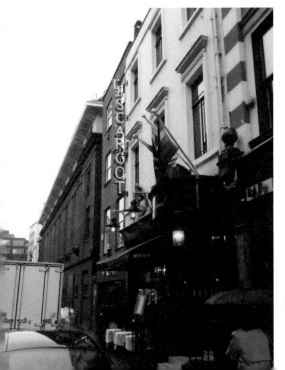

L'Escargot, Greek Street.

F

Fitzroy Tavern – A Magnet for Bohemians

While Soho can boast a handful of truly historic and characterful pubs, Fitzrovia has a few notable hostelries of its own, chief among them the Fitzroy Tavern, on the corner of Charlotte Street and Windmill Street.

Starting life as the Fitzroy Coffee House in 1883, it was transformed four years later into a pub, The Hundred Marks, and directories record that the landlord in 1895 was one Heinrich Hundertmark. During the late nineteenth and early twentieth century this part of London had a large community of German immigrants living and working in it: not for nothing was Charlotte Street once known as Charlottenstrasse.

In 1919, now with Russian émigré Judah Morris Kleinfeld at the helm and much animosity directed by Londoners towards Germany and Germans following four years of war, the pub adopted its current name. From the 1920s through to the late 1950s, under first the stewardship of 'Papa' Kleinfeld and then his daughter Annie

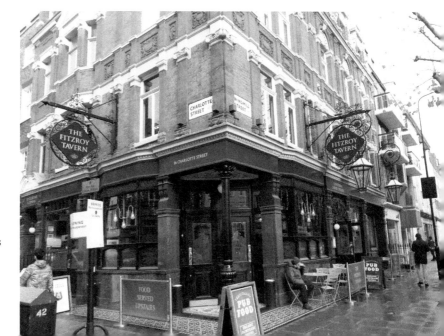

Right and overleaf: The Fitzroy Tavern is Fitzrovia's best-known pub.

and her husband Charlie Allchild, the pub enjoyed a golden age as one of pre-eminent drinking hangouts for many 'bohemians' of the day.

Known affectionately by many as Kleinfeld's, sometimes as Klein's, through its doors stumbled the likes of writers George Orwell, Dylan Thomas and Julian Maclaren-Ross, the sculptor Jacob Epstein, the so-called 'Queen of Bohemia' Nina Hamnett and the painter Augustus John, to name just a few. Indeed John once compared the Fitzroy to Clapham Junction railway station because 'everyone passed through there sooner or later'.

This motley crew of bohemians would often find themselves in a packed pub rubbing shoulders with local drinkers and, in the words of Paul Willetts, author of *Fear and Loathing in Fitzrovia*, occasionally 'bell-bottomed sailors on shore leave', many of whom would no doubt have been drinking the house speciality, Jerusalem Brandy.

The pub's ceiling was famously covered in banknotes from all over the world, attached by darts, which were taken down regularly, the proceeds donated to the Pennies from Heaven children's charity.

Converted into a pub by the architect WM Brutton in 1887, and described a little unfairly by Mark Girouard in *Victorian Pubs* as 'elaborate but a little fussy', it is today in the hands of the Yorkshire brewer and pub company Samuel Smiths. It underwent an award-winning and sympathetic restoration back in 2018, and while it isn't quite the bohemian magnet of yesteryear, it is still one of the area's essential watering holes.

Foyles – Idiosyncratic Bookshop Famed for Its Luncheons

Although there have been trials and tribulations aplenty during its long and colourful history, Foyles remains one of the best-known bookshops in the world, although today is much altered compared to its humble beginnings.

In 1903, having both failed their entrance exams for a career in the civil service, brothers Gilbert and William Foyle, eighteen and seventeen years old, respectively,

decided to sell their no longer needed textbooks from their home just off the City Road. The response to their ad convinced them there was a huge demand for books, and the following year they opened their first small shop in Cecil Court, still an enclave of bookshops near Leicester Square.

Two years later the brothers moved to larger premises in Charing Cross Road, and in 1929 transferred the business to the 'first purpose-built' bookshop in the world, located on the corner of Charing Cross Road and Manette Street. It was from these premises that Foyles became one of the best-known book retailers in England, with a reputation that ensured the name was known across the globe.

A double-queuing system of buying books was either endearing or annoying, depending on your point of view, but certainly highlighted their reputation for eccentricity. Their mail-order service proved enormously successful, receiving an estimated 35,000 enquiries a day at its height in the 1950s, while they also ventured into the rare stamp-selling business.

In the 1930s, Christina Foyle, daughter of William, started to host literary luncheons that would enable ordinary readers to meet famous authors. Although modest in scale to start, at their height these events could attract as many as 2,000 people and writers as esteemed as JM Barrie, George Bernard Shaw and HG Wells.

The shop survived the Blitz, although a giant crater was immediately created outside the shop after one German raid. A temporary bridge was soon erected across this crater to reconnect the two sides of Charing Cross Road. As William Foyle had fed and watered the sappers responsible for the crossing, it was named the Foyle Bridge in his and the shop's honour.

In 2014 Foyles moved a matter of yards along the Charing Cross Road to a sumptuous new store located in part of the former St Martin's College of Art building, boasting some 4 miles of shelves. In 2018 they were bought by the giant book chain Waterstones, although thankfully the Foyles name and brand have been retained.

Foyles have been trading in Charing Cross Road since 1929. (Daniela Rosello)

Gay Hussar – Goose, Goulash and Gossip in Greek Street

Established in 1953 at No. 2 Greek Street, and until its closure in the summer of 2018, the Gay Hussar was a restaurant that attracted a loyal band of customers, many of them from the worlds of politics, publishing, journalism and law.

The food, which it's fair to say never enjoyed universal praise, seems to have been of secondary importance. People dined at the Gay Hussar to share gossip – mostly political gossip – or perhaps discuss an idea for a book with their publisher (the publisher always paid, naturally). They did so in surroundings that were possibly considered contemporary in the early 1950s, but over the years had become somewhat fusty.

The Gay Hussar was founded by Victor Sassie, who despite his exotic-sounding name actually hailed from Barrow-in-Furness and was of Swiss/Welsh parentage.

When Sassie was seventeen years old, in 1932, he was dispatched to Budapest by the British Hotel and Restaurant Association to serve an apprenticeship under the

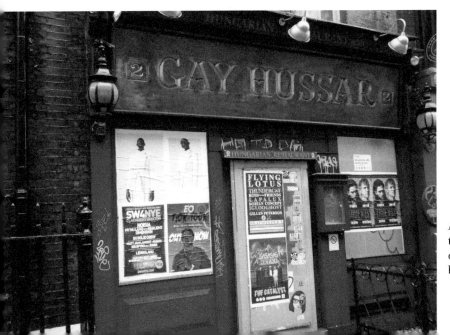

A sad sight – the Gay Hussar closed for business.

tutelage of Karoly Gundel, a celebrated Hungarian chef of the day. Sassie also spent time in Vienna before returning to England in 1939, opening a restaurant called Budapest in Dean Street.

In the Second World War he served with British Intelligence, posted at one point to Hungary, and once hostilities had ended he returned to London to open a second branch of Budapest, this time in Frith Street.

However it is the Gay Hussar that endured and for which he is best remembered. Over the years it found great favour with politicians, in particular those left of leaning. Loyal returning customers included Michael Foot, Aneurin Bevan, Tom Driberg and Barbara Castle, while many of the great and good from the London publishing world were also regulars, among them TS Eliot.

The restaurant made the front page of the *Daily Mail* in the early 1970s when the Union of Shop, Distributive and Allied Workers hosted a Soviet delegation in the Greek Street eatery. The final bill, which the *Mail* had managed to obtain, was of eye-watering size and, perhaps more importantly, the story also seemed to suggest that the Hussar was a hotbed of espionage.

Sassie retired in 1988 and devoted the rest of his life to his other great passion, horse racing. The Gay Hussar ambled on without its founding father but in June 2018 closed its doors for the last time to end another chapter of Soho history.

The George – Genuine Local in the Heart of Soho

Soho and Fitzrovia can boast between them a handful of very famous pubs, but rarely mentioned are the genuine workaday locals which just get on with the business of being very good pubs serving very good beer. The George, on the corner of D'Arblay Street and Wardour Street, is an excellent example.

There's been a pub on this site since at least 1739, and the current rather elegant building dates from 1897 when it was built for the brewer Meux and Co., who were based at the famous Horseshoe Brewery in nearby Tottenham Court Road. The Horseshoe was the scene of the infamous Great Beer Flood of 1814 during which more than three million pints of beer, mostly porter, burst from a number of vessels to decimate the immediate local area. Eight people died in the incident.

At the time the incident spelt financial disaster for Meux and Co., but they had recovered sufficiently some seventy-three years later to lavish some obvious investment in the George. The building has enjoyed Grade II listing since 2010 and remains a small but perfectly formed pub that retains many of its original features, most notably in the compact ground-floor bar where you will not only find painted mirrors for both Mitchell and Co.'s Cruiskeen Lawn Irish Whiskey and HD Rawlings' mineral water, but another lavish example of the form proclaiming the 'celebrated' ales of Meux and Co.

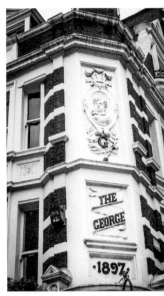

Above left and above right: The George has been trading in Soho since 1739.

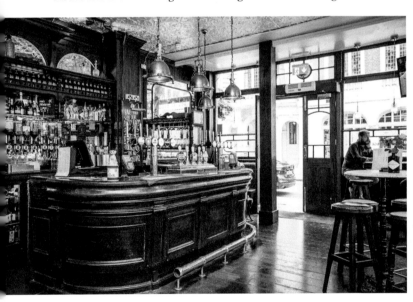

Above left and above right: The pub's interior includes an original Meux and Co. painted mirror.

The George, like several thoroughly decent Soho pubs, doesn't get mentioned in many histories of the area. But it's been here, in one form or another, for more than 280 years and, I am pleased to report, is still going strong, courtesy these days of the Kent brewer Shepherd Neame, attracting a lively mix of media types, locals and those working in the film industry.

H

Huggins Brewery – The Sweet Smell of Hops in the Heart of the West End

As one saunters through today's Soho, it's hard to comprehend that a number of heavy industries once thrived here, among them the Lion Brewery in Broad Street, which today we know as Broadwick Street.

In 1801, William Thomas Stretton started a small brewery at Nos 49 and 50 Broad Street. The Lion Brewery was rather compact to start but grew rapidly. By 1811, trading as Stretton and Co., it produced 24,362 brewers barrels of beer – around seven million pints.

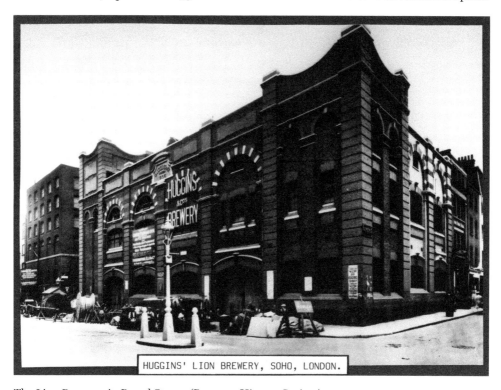

HUGGINS' LION BREWERY, SOHO, LONDON.

The Lion Brewery in Broad Street. (Brewery History Society)

By 1822, with Stretton departed and James Goding and Henry Broadwood on board, the company, now known as Goding and Broadwood, were described as London's 'principal ale producer' in records showing that over a twelve-month period between July 1822 and July 1823 they sold 28,538 barrels of ale, putting them ahead of such brewing giants of the day as Barclay Perkins, Truman and Whitbread, all principally producers of porter at the time. Although to give this some context, over the same period Barclay Perkins brewed more than 350,000 barrels of porter.

By 1824 the Lion Brewery took up the whole of the south side of Broad Street between Hopkins Street and New Street (New Street was renamed Ingestre Place in 1853). However in 1835 there seems to have been a falling out between Broadwood and Goding, the latter departing to set up a new brewery in Lambeth, which opened in 1836 and traded until 1924, also as the Lion Brewery.

Back in Soho, trading as Broadwood Mundell and Co., the Broad Street brewery staggered on, until by 1850 the Huggins family had taken control. They would oversee continued production at the site, under a number of slightly different names, well into the twentieth century.

The International Brewers' Journal of 1898 reported that Huggins Brewery had 'a capital of £1,400,000', noting that 'since the date of incorporation of the old company [1894] the business has very largely increased'. This did not stop it from going into voluntary liquidation, also in 1898, although a new company rose instantly from the ashes.

As home to Huggins and Co., the Lion Brewery was a substantial building, and a sizeable industrial operation, in the very heart of the West End. In addition to its long Broad Street frontage, it also stretched down both Hopkins Street and New Street.

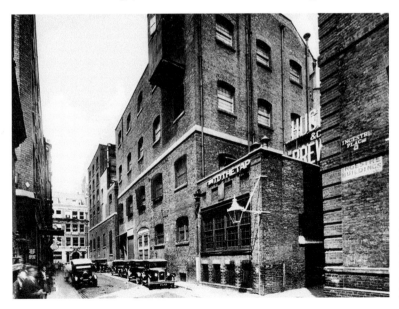

The Lion Brewery, Ingestre Place elevation. (Brewery History Society)

Above left, above right and right:
Huggins ales were brewed until 1928.

In the late summer of 1928 Huggins were bought by Watney, Combe, Reid. With Watney's sizeable Stag Brewery still active in Victoria, production ceased at the Lion Brewery and the Huggins brand promptly disappeared.

Watney's main drive in buying Huggins was the company's London pub estate. It totalled more than a hundred houses with many in prominent and, one assumes, lucrative locations.

The Lion Brewery itself stood empty for several years until demolition in 1937. On the site was built the monolithic Trenchard House, a Metropolitan Police section house. This closed in 1999 and was demolished in 2013. The site is now occupied by a new Trenchard House, a modern block offering a mix of 'affordable' and private housing with shops occupying the ground floor.

Huguenots – The French Arrive in Soho

Although there had been a Huguenot presence in London since at least the mid-sixteenth century, when King Louis XIV revoked the Edict of Nantes in 1785 an estimated 40,000 of these French Calvinist Protestants, fleeing religious persecution in their homeland, descended on London, granted Sanctuary by Charles II. And while Spitalfields in the East End is the area most associated with them, a large proportion of these refugees washed up in Soho and its immediate districts.

It is the principal reason why, for much of the eighteenth, nineteenth and early twentieth centuries, Soho had such a strong Gallic feel to it. Writing in 1915's *Nights in Town*, Thomas Burke declared of the area:

> Here in this little square mile of England is France: French shops, French comestibles, French papers, French books, French pictures, French hardware and French restaurants and manners.

An eighteenth-century depiction of the French Church, Soho Square.

40

Many of the Huguenot arrivals in Soho were skilled artisans: jewellers, silversmiths, clockmakers, watchmakers and much more besides. They established small businesses in the area, and this model of business continued to thrive in Soho well into the twentieth century, although are sadly few and far between now.

To cater for this Huguenot influx numerous places of worship were soon established. The first had originally been designed to cater for the many Greek refugees who had preceded the French in Soho, but when they fell behind with the rent the Huguenots took charge of this chapel. It was situated in Hog Lane, near today's Greek Street. Further Huguenot chapels followed, notably in Berwick Street (which had two), Milk Alley (today's Bourchier Street) and Orange Street, near today's Leicester Square, upon which site today stands the Orange Street Congregational Church.

Italian, German and Swiss immigrants would later descend on Soho, all helping to give the area its unmistakeably cosmopolitan air. And although the French don't dominate the area as they once did, their mark can still be seen today.

In Soho Square can be found the French Protestant Church of London, which was commissioned in 1881 but not completed until 1893 due to delays in being granted permission from the Attorney General to go ahead with the project, permission which was eventually forthcoming in 1890. It was designed by Sir Aston Webb, better known for his work on Buckingham Palace and the Victoria and Albert Museum. According to Christopher Hibbert's *London Churches*, Webb always regarded the Soho Square church as 'the favourite of his buildings'. Its dark façade of black brick and brown terracotta is certainly striking and the building is Grade II listed.

There is another notable French place of worship in Soho, namely Notre Dame de France, in Leicester Place just off Leicester Square. Parts of this remarkable building can be traced back to the late eighteenth century when it housed Burford's Panorama, but it was obtained in 1865 by Father Charles Faure, who had been charged by the Archbishop of Westminster to build a Catholic place of worship to cater for Soho's sizeable French population.

The church was consecrated in 1868 and served generations of French Londoners before being largely destroyed by German bombing in 1940. The current church was designed by Professor Hector Corfiato in a modern style of Beaux Arts, and was completed in 1955. Among the interior features are a number of wall paintings by Jean Cocteau.

Intrepid Fox – Rock 'n' Roll Hangout

Given that Soho is believed to have acquired its name from an old hunting cry once used when the area was mostly rural, and the 'sport' of fox hunting was popular, it comes as a surprise to learn that the Intrepid Fox pub, a Wardour Street landmark for many years, acquired its name for a very different reason.

There are records of a public house on the corner of Wardour Street and St Peter's Street from at least the 1760s, originally trading as the Gravel Pit, and directories show that Samuel House was landlord here in 1763. House was known as 'The Patriotic Publican' and enjoyed a certain degree of celebrity in his day,

When a General Election was called in 1784, House pledged his allegiance to Charles James Fox, who was attempting to hold onto the seat of Westminster, the constituency that included Soho.

Fox had been a Whig thorn in the side of Tory Prime Minister William Pitt for many years and there was no love lost between the two. The subsequent campaign for the Westminster seat would prove an especially bitter one, not without the odd gimmick.

According to the Tories, Georgina, Duchess of Devonshire, considered one of the great beauties of the age and a Fox supporter, toured the local streets and offered a kiss to anyone who promised to vote for Fox.

Sam House, meanwhile, offered free beer to anyone who frequented his pub during the election period and promised to support Fox. Fox was a regular at the pub and House changed the name of his tavern in honour of his friend.

When the votes had been counted Fox had won a close contest, but Tory objections to the result, and to some of Fox's tactics, meant he wasn't returned as Member of Parliament until almost a year later.

Apart from a brief period in the late nineteenth century when the pub was known as the Swiss House Distillery, it remained the Intrepid Fox until it closed in 2006. A chain burger bar currently occupies the premises.

For many years the Fox was a popular drinking haunt for those working locally in the music and film business, and was latterly a hang-out for fans of Goth and heavy metal music. Both Mick Jagger and Rod Stewart were known to drink here.

The current building's exterior still features a relief of fox.

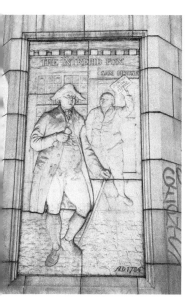

Above and right: The Intrepid Fox, Wardour Street. (Daniela Rosello)

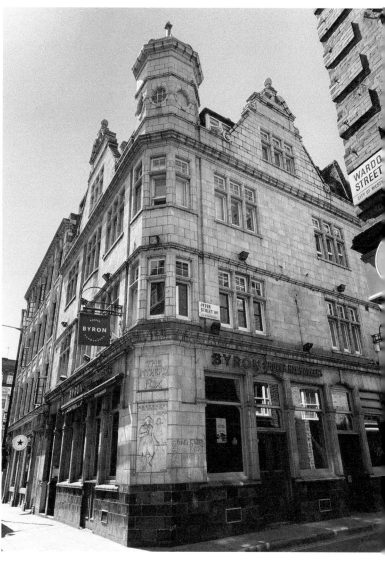

John, Augustus – Artist, Drinker, Womaniser

For many who have chronicled Soho and Fitzrovia, the late 1940s into the 1950s was the area's golden age: a time of bohemians and debauchery, of larger-than-life characters for whom excess and overindulgence were part of day-to-day life. One of the older cast members of this remarkable real-life drama was the painter Augustus John, a gifted artist who over the years became almost as well-known for his drinking and promiscuity.

Born in Tenby, Pembrokeshire, in 1878, an early love of drawing was furthered by a brief stint at Tenby School of Art before enlisting at London's Slade School of Art, where he was widely regarded as a stand-out student.

Although he was a regular at several pubs and clubs in the area in the post-war years, his connection with Soho can be traced back to before the First World War. In April, 1914 he established a nightclub above a leather wholesalers at No. 17 Greek Street. Called the Crab Tree, it consisted of several interconnected rooms and attracted a bohemian clientele, including the sculptor Jacob Epstein and the painter Walter Sickert. By all accounts it was a very informal place, and anyone who dared turn up in evening dress was promptly fined a shilling.

The club didn't remain open for long, however, closing soon after the start of the First World War in July 1914, during which John was attached to the Canadian forces as a war artist. This arrangement seems to have come about largely through the influence of the newspaper magnet Lord Beaverbrook, owner of *The Daily Express*.

Although he had been well known prior to 1914, it was after the war that John's reputation as perhaps England's foremost portrait painter was made. Among the great and good to sit for him were Thomas Hardy, James Joyce (who hated the finished work), TE Lawrence (Lawrence of Arabia as he was better known) and a positively cherubic-looking Dylan Thomas. The Lawrence portrait can still be seen at Tate Britain, while the Thomas picture resides at the National Portrait Gallery.

In later years, now something of an elder statesman among his fellow bohemians, he was a regular in the Café Royal's Domino Room, buying drinks for impoverished hangers-on, and could also be found with the usual suspects in the likes of the French pub, the Fitzroy Tavern and the infamous Colony Room .

John's promiscuity is the stuff of London bohemian legend. An often-told anecdote is that he was unable to walk along Charlotte Street (some versions suggest the King's Road, Chelsea) without patting the head of every child he passed, just in case it was one of his own.

He died in 1961 in the New Forest town of Fordingbridge.

Kettner's – Agatha Christie Ate Here

First opening its doors in 1867, Kettner's is reckoned to be one of the first restaurants in London outside the grand hotels to offer classic French food. Over its 150-year history it has grown and diversified, becoming a much-loved institution both to the denizens of Soho and further afield.

Now dominating one corner of Greek Street and Romilly Street, it started more modestly in Church Street, which became Romilly Street in 1937. Much 'knocking through' has given us toady's sizeable establishment.

Originally calling itself the Restaurant du Pavilion, in 1869 it was acquired by Auguste Kettner and the name changed accordingly. A letter to *The Times*, published the same year, was highly complimentary, the writer declaring the food as 'better than he could have obtained at a West-End club'.

Although the cuisine on offer was French, Kettner himself was German and born in Berlin in 1833, although he did learn his trade in Paris. One of the myths surrounding him, often repeated, is that he was once personal chef to Napoleon III. There seems to be no historical evidence to back this up.

Kettner spent less than a decade in Soho, for in 1877 he died. This was also the year that saw the publication of his *Book of the Table*, which was mostly ghost-written to cash in on his reputation.

Upon Kettner's death the restaurant passed to his widow, Barbe. In 1880, aged forty-six, she married Giovanni Sangiorgi, an Italian fifteen years her junior who had worked at Kettner's for a number of years. This marriage would last until Barbe's death in 1893.

History recalls that it was Sangiorgi who orchestrated Kettner's transformation into one of London's most famous restaurants, frequented by the great and the good. It was a favourite haunt of Oscar Wilde and also King Edward VII, who is known to have met Lillie Langtry here, no doubt taking advantage of the private upstairs rooms.

Later still Agatha Christie was a regular customer.

In 1914's *Gourmet's Guide to London*, Nathaniel Newnham-Davis wrote of the restaurant's policy – then almost unheard of – of allowing diners to inspect the

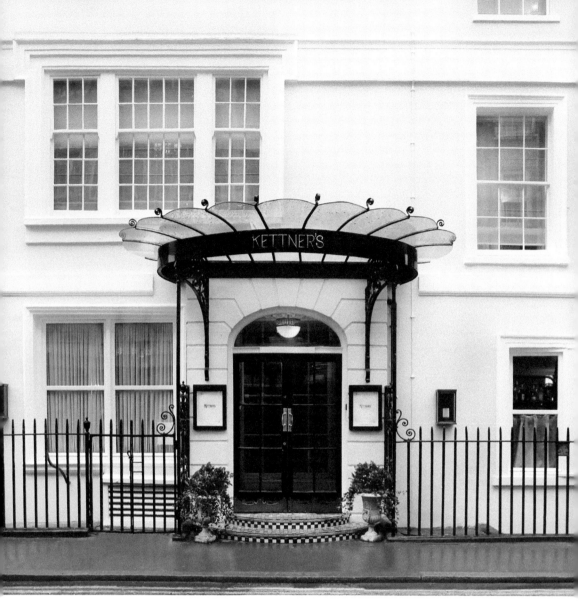

Kettner's was one of London's earliest French restaurants.

kitchen. He wrote, 'It was a real chef's restaurant ... where a walk through the kitchen and an inspection of the larder always preceded or followed a dinner.'

In 1980 Kettner's was acquired by Peter Boizot, founder of the Pizza Express chain. The French menu had disappeared many years previously, and now the food was upmarket pizza and burgers.

In 2016 Kettner's closed its doors after almost 150 years of business, reopening in 2018 under the ownership of the Soho Group. It now comprises a restaurant and thirty-three hotel rooms. The famous Champagne bar is still here too.

L

Leicester Square – Entertainment Hub

Today's Leicester Square is one of London's main entertainment hubs, a brash neon riot of cinemas, nightclubs, casinos, shops and restaurants situated on the southern edge of Soho. It is not to everyone's taste.

It was once, however, one of the capital's most fashionable addresses, and its famous residents down the years included a number of aristocrats in addition to the artists William Hogarth (1733–64) and Sir Joshua Reynolds (1760–92).

The area's development as a residential area started in 1630 when Robert Sidney, the 2nd Earl of Leicester, set about building Leicester House on the northern part of the land he had recently acquired. The house wasn't finished until 1635 and was reckoned to be the biggest private residence in London. It was demolished in 1792, and the site is today occupied by Leicester Place and parts of Lisle Street.

Below and opposite: Leicester Square today and dominated by the Alhambra Theatre, *c.* 1920. (Daniela Rosello)

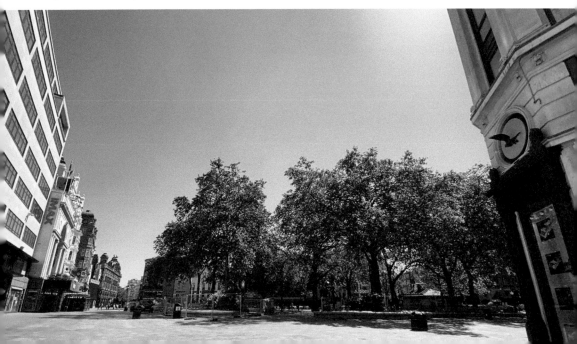

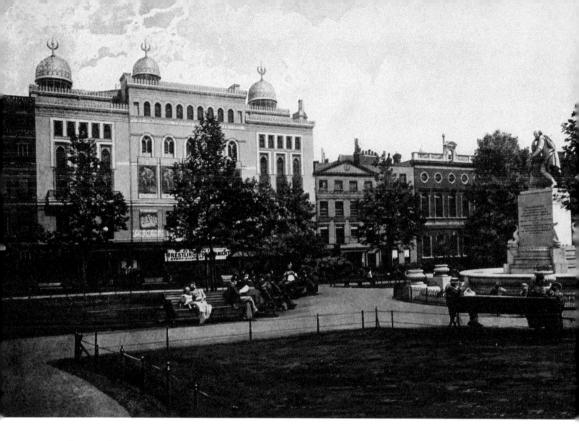

The southern part of the area was known as Leicester Fields and laid out as Leicester Square from the 1670s onwards.

By the 1850s the area was beginning to become more commercial, and already developing as a place of entertainment. In 1851 James Wyld's Monster Globe was erected, a huge brick building with a domed roof which housed a globe, some 60 feet in diameter, inside which could be seen a 'delineated' representation of the 'physical features of the earth'. Always controversial, it was demolished in 1862.

In 1854, on the square's eastern side, the Royal Panopticon of Science and Art (the Panopticon as it was more widely known) opened. It cost £80,000 to build, a huge amount at the time, and was constructed in a 'Moorish' style. The project always struggled and in 1858 was bought at auction by ET Smith, a theatre manager with a gift for publicity. It reopened in April that year as the Alhambra Palace Theatre, a venue that would become one of London's most popular entertainment venues, loved for its mixture of Music Hall and more exotic fayre, including trapeze acts and light operetta.

After being mostly destroyed by fire in 1882 it was rebuilt, with the original surviving façade, and if anything proved even more popular than before. However, entertainment was changing with the advent of cinema, and in 1936 the majestic old Alhambra went the way of the wrecking ball, replaced in 1937 with the monolithic art deco Odeon Cinema that still dominates the square today.

The Empire, on the eastern side of the square, first opened as the Empire Theatre in 1884. It too was demolished, a decade or so before the Alhambra, and rebuilt as a cinema in 1927.

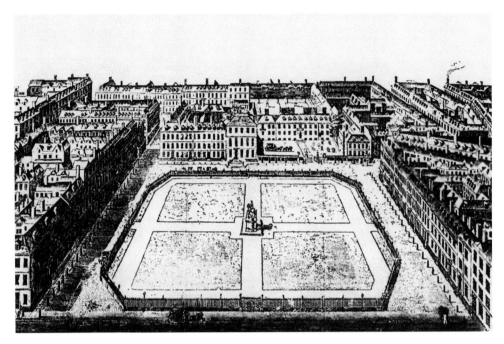

The square, pictured in the early 1700s.

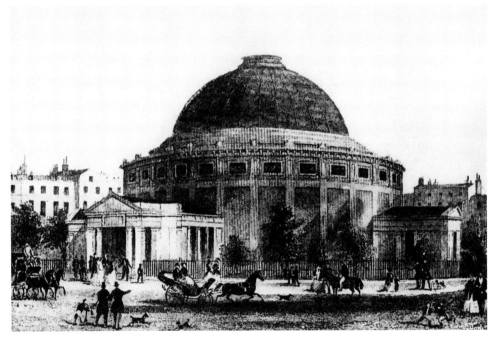

Wylde's Monster Globe, 1851.

M

Marquee Club – Legendary Music Venue

Even though it closed its doors for the last time many years ago, the Marquee Club remains, arguably, the most famous venue in rock and roll history. Over its long, and sometimes troubled, five decades it offered a stage to artists that would later go on to great things, among them The Rolling Stones, The Who, David Bowie, Pink Floyd and a nascent Led Zeppelin.

The club was the brainwave of Harold Pendleton, an accountant by trade with a passion for jazz. Pendleton was secretary of the National Jazz Federation, an organisation that promoted live Trad Jazz concerts at a variety of different venues. On 19 April 1958 a permanent venue was established in the basement of The Academy, an arthouse cinema located on the corner of Oxford Street and Poland Street. The venue was called the Marquee Ballroom.

Although Pendleton was a Trad Jazz man through and through, as the 1960s unfolded he grew increasingly aware of the growing popularity and commercial clout of rhythm and blues music (R&B), and from 1962 onwards the Marquee's musical policy shifted to allow visiting US performers such as Muddy Waters to appear.

It was also in 1962 that a relatively unknown London band called The Rolling Stones played at the club for the first time, and by 1963 the Marquee was primarily an R&B venue.

When the lease on the Oxford Street site expired, the club was forced to relocate and on the night of 13 March 1964 the Marquee Club opened its doors for the first time at No. 90 Wardour Street. Headlining was American bluesman Sonny Boy Williamson, on a bill that also included Long John Baldry, a young Rod Stewart and The Yardbirds.

Of the various locations at which the club was based, it is the Wardour Street site that became the stuff of legend. The list of artists to appear at the Marquee between 1964 and its eventual relocation in 1988, reads like a who's who of rock royalty. In addition to the acts mentioned earlier, among those to tread the venue's tiny stage were AC/DC, Cream, Dire Straits, Manfred Mann, Jethro Tull, King Crimson, The Moody Blues and future prog rock giants Genesis and Yes.

Although never regarded as a punk venue, The Damned, Generation X, The UK Subs and The Sex Pistols all played here, although the Pistols were subsequently barred for damaging the equipment of headline band Eddie and the Hot Rods. Subsequently,

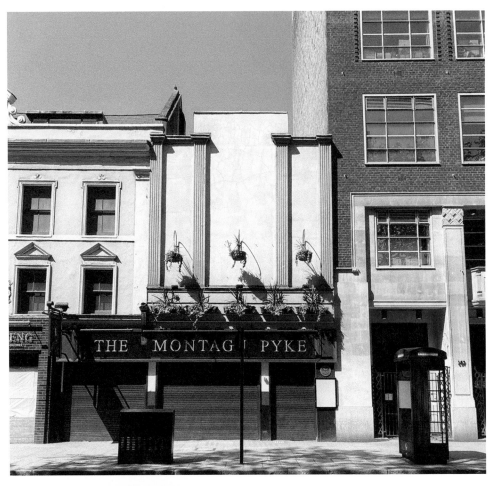

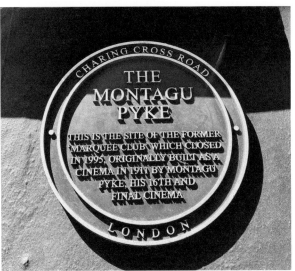

Above and left: The Marquee
Club remembered at its former
Charing Cross Road site, now a
pub. (Daniela Rosello)

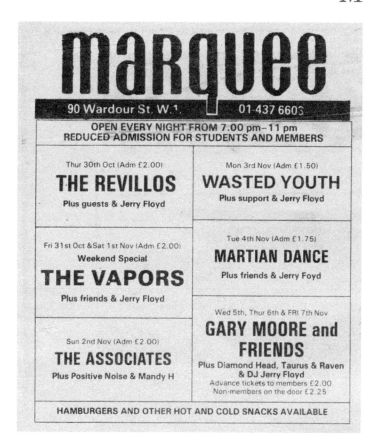

A typical week's line-up at Wardour Street, from September 1980.

post-punk bands such as The Cure, The Jam, Joy Division, The Police, Ultravox! and U2 all appeared.

In the 1980s the Marquee was one of the prime venues for the so-called new wave of British heavy metal movement.

In 1988 the Marquee Club was bought by Billy Gaff, former manager of Rod Stewart. The Wardour Street site was subsequently redeveloped, the club closing and relocating to much bigger premises in the former Cambridge Circus Cinematograph Theatre in nearby Charing Cross Road. Joe Satriani was the last to play at the old Marquee, American rockers Kiss the first to play at the new venue.

However, the club struggled at its new location and closed in December 1992. It subsequently opened at a variety of London locations but was never the Marquee of old, closing for the last time in 2008.

The Wardour Street site was completely redeveloped back in the late 1980s. Here now you'll find a tombstone-like plaque featuring a strangely arbitrary list of artists, and a separate blue plaque in honour of late Who drummer Keith Moon. These are the only physical reminders of a once legendary rock venue.

Newman Arms – Immortalised by Orwell

To the casual observer the Newman Arms in Rathbone Street must seem like a pretty ordinary London pub, but one doesn't have to dig too deep to discover that this lovely, albeit compact, old boozer has a fascinating and colourful history.

The building we find today dates from around the 1740s. Around this time this once bucolic area was being developed as part of the Berners Estate. Initially it did not trade as a tavern and was believed to have been used by a candlemaker. At some point between then and becoming a public house – it was certainly licensed by the 1860s – it housed a brothel.

It is without doubt the smallest pub in Fitzrovia and was one of the last in the area to be in possession of a beer-only licence, which was the case until after the Second World War and effectively meant it could not sell wine or spirits (it was granted a wine licence in 1948 and a spirit licence in 1960). It was, thus, known affectionately for many years as the Beer House.

A well-known stopping point on any self-respecting bohemian's pub crawl, it was certainly very well known to George Orwell. Orwell clearly loved public houses, as his famous 1946 essay on just what constituted his idea of the 'perfect pub' illustrates, and he was familiar with most of the hostelries of both Fitzrovia and Soho.

The Newman Arms, however, really seems to have got beneath the great man's skin and although not directly named turns up as a location in both *Keep the Aspidistra Flying* (1936) and *Nineteen Eighty-Four* (1949).

In the latter book it is the 'proles' pub which Winston Smith illicitly visits, while in the former the central character Gordon Comstock meets a friend, Ravelston, in the pub with the two men soon engaging in heated political discussion.

Running along one side of the pub is the wonderfully atmospheric Newman Passage, which connects Rathbone Street and Newman Street. Back in 1872 a co-operative soup kitchen was opened here to feed French refugee communists in exile.

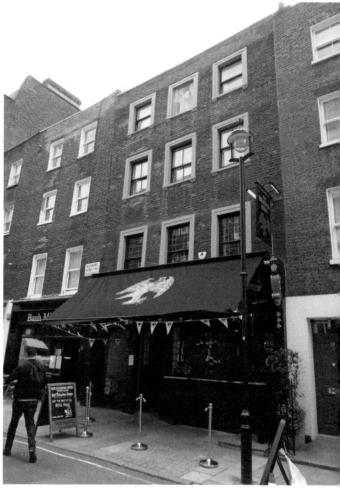

Above and right: The Newman Arms and 'Jekyll and Hyde Alley'.

The passage is best known as the location for the first murder in Michael Powell's controversial 1960 film *Peeping Tom*, which tells of a photographer who picks up prostitutes and films them as he murders them. The film all but ended Powell's career.

The writer Julian Maclaren-Ross once referred to Newman Passage as 'Jekyll and Hyde Alley', describing it as 'where one sometimes guided girls in order to become better acquainted'.

In 2018 the revived Truman's of East London acquired the Newman Arms, their first pub since the famous old brewer was re-established back in 2010

Old Coffee House – From Temple of Temperance to Proper Pub

Despite its name, the Old Coffee House in Beak Street is very much a pub, and in fact is one of Soho's finest, full of character and characters.

The earliest record of a place of refreshment on this site dates from 1772 when the Silver Street Coffee House stood here. This eastern end of Beak Street was formerly known as Silver Street – hence the name.

As long as there have been people who wanted to drink alcohol, there have been people who wanted to stop them. The temperance movement in England, for instance, has proved itself a powerful and well-organised pressure group throughout history and was perhaps at its height in the nineteenth century, particularly vociferous in its targeting of the working classes in poorer areas.

The temperance movement had a variety of ways of going about their work – they liked to march and they loved to preach – including the rather ingenious concept of operating temperance pubs, a strategy described by Mark Girouard in *Victorian Pubs* as 'carrying the war into the enemy's country'. For years the movement had operated coffee shops, and eventually some bright spark came up with the idea of coffee pubs.

These establishments were intended to have many of the qualities of the public house – places for social gathering, the exchange of information and perhaps even food – but without the demon alcohol. Often these establishments looked like pubs and were even run along the same lines as pubs, but instead of beer or gin the customer could choose from cordials, alcohol-free delights such as Anti-Burton (which was probably as disgusting as it sounds) and, of course, hot beverages such as tea or coffee. All served, naturally, with a generous helping of Christian preaching. London alone had as many as 120 of these coffee pubs.

The idea of temperance pubs proved unsuccessful. Many of the buildings were subsequently turned to other uses and a few, oh delicious irony, became proper pubs. Among them, the Old Coffee House.

The current building dates from 1894 and is just a little eccentric. For the record, the Old Coffee House still sells coffee.

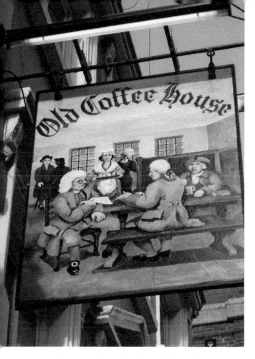

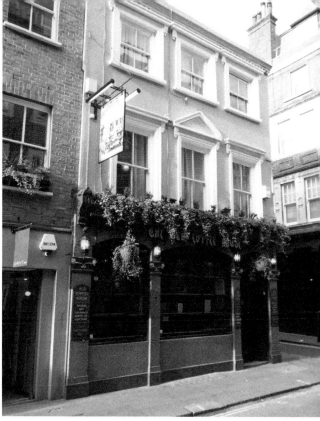

Above and right: The Old Coffee House, Beak Street.

Old Compton Street – Soho's High Street

Old Compton Street runs west from Charing Cross Road to Wardour Street. It is, effectively, Soho's high street, a busy thoroughfare of shops, cafés, restaurants and pubs. Over the past three decades or so it has also developed into the centre of London's gay scene, with many of the bars and shops reflecting this.

Compton Street, as it was originally known, was one of the earliest Soho streets to be developed, from the 1670s onwards. It is named in honour of Henry Compton, Bishop of London. It seems that from early on this was a street of shops and records show that by the 1790s only a handful of houses did not have shopfronts at street level. The influx of Huguenots into the area was by then well underway, and many of these exiles from France were shopkeepers or artisan craft workers.

Old Compton Street has long been the cosmopolitan heart of cosmopolitan Soho. Here French immigrants would congregate, for Soho was for many years little France in London, and emigres who had arrived following the failure of the 1871 Paris Commune could here swap gossip and peruse political pamphlets in relative safety. Poets, and lovers, Verlaine and Rimbaud would hang out in Old Compton Street's cafés and public houses, their stormy relationship sometimes played out in public.

In his 1915 book *Nights in Town*, Thomas Burke writes extensively about Old Compton Street in the chapter titled *A French Night*. In one passage he declares that

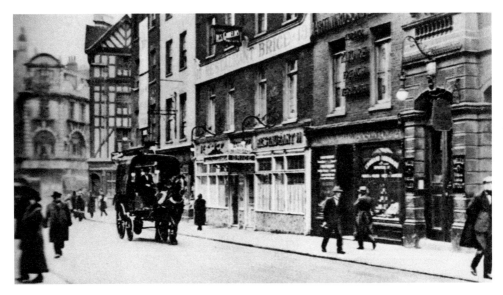

Above and below: Old Compton Street in 1920 and 2020. (Daniela Rosello)

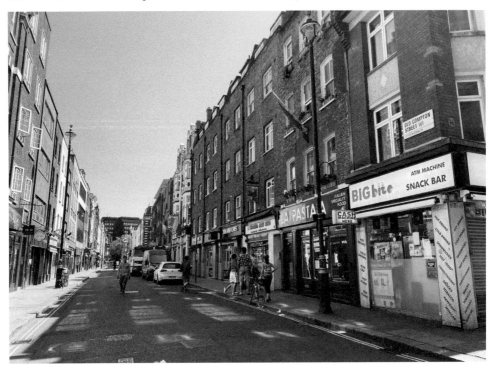

'when the respectable Londoner wants to feel devilish he goes to Soho ... He walks through Old Compton Street, and, instinctively, he swaggers; he is abroad; he is a dog.'

Years later the Italians who followed the French also left their mark on the street, and over time it became a place renowned for its restaurants.

At No. 19 was Wheelers, specialising in seafood and in particular oysters. It was opened in 1929 by Bernard Walsh, initially as a wholesaler of seafood. Walsh had started in the family business in Whitstable – hence the oyster connection – and soon turned his wholesale business into a restaurant.

Wheelers enjoyed its golden age in the 1950s when it was a favoured haunt of Soho bohemians, in particular the group that centred on Francis Bacon and included Lucian Freud and Frank Auerbach. Bacon often picked up the bill.

Wheelers was also home to the Thursday Club, a weekly private dining club among whose members were a number of national newspaper editors of the day, the actor James Robertson Justice, the musician Larry Adler and, on one occasion, Prince Philip.

Wheelers closed in 1999.

At No. 54 is the Admiral Duncan pub. There's been a pub of this name here since the 1830s and it is one of Soho's oldest recognised gay pubs. On the evening of 30 April 1999, a nail bomb exploded here, killing three people and seriously injuring another seventy-nine. Neo-Nazi David Copeland, who had previously left similar devices in Brixton, south London and Brick Lane, east London, was captured and convicted of the bombings. He was sentenced to six concurrent life terms.

On the other side of Old Compton Street, at No. 53, is Compton's, arguably London's most famous gay pub. It is first recorded here in the early nineteenth century, originally called The Grapes. It changed its name in the 1850s to the Swiss Tavern and Hotel, one assumes to reflect (and hopefully attract) the many Swiss who had settled in the area.

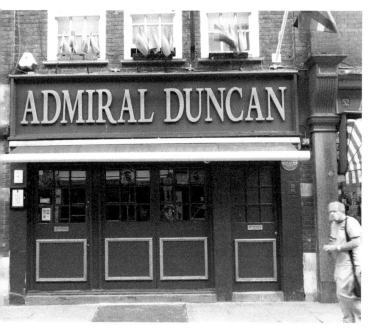 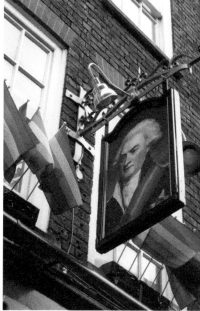

Above left and above right: The Admiral Duncan is one of London's best-known gay pubs.

At some point in the 1980s it became the Compton Arms, later shortened to Compton's. The current, rather florid building we have today dates from 1890 and was designed by the architectural firm WA Williams and Hopton, although it has been much altered over the years.

Our Lady of the Assumption and Saint Gregory – Neglected Gem of a Church

The Church of Our Lady of the Assumption and Saint Gregory, tucked away just off Golden Square in (relatively) sleepy Warwick Street, is for me one of Soho's hidden treasures.

Some sources suggest a place of worship has stood here since 1730, originally as the chapel attached to the Portuguese Embassy, but it could have been earlier in a very modest form. The fine Georgian houses at Nos 23 and 24 Golden Square, next to the church, were home to Marques de Pombal, Portuguese Ambassador to England from 1724 until 1747.

Public Catholic places of worship were not allowed at this time, but foreign embassies were permitted to have their own chapels. In the case of de Pombal, this was essentially built to the rear of the Embassy residence.

When the Portuguese relocated their embassy to South Street, Mayfair, the lease was acquired by Count Haslang, the Bavarian envoy, and so the chapel became the Royal Bavarian chapel. However it was targeted by a mob during the Gordon Riots of 1780, and over 2 and 3 June was, according to Horace Walpole, 'broken open and plundered'.

Aware of what was probably coming, Haslang managed to save some silver plate and ornaments. He had petitioned the authorities for protection, but it arrived too late.

With anti-Catholic sentiment somewhat abated, worship started again here by 1783, but when the Bavarians left in 1787 James Talbot, Bishop of the London district, managed to secure a long lease on both the chapel and its two connected houses. The chapel was subsequently rebuilt over 1788 and 1789 on a grander scale, opening in 1790, and this is the understated but rather elegant Grade II listed building we have today. It was consecrated in 1928.

Christopher Hibbert, in *London's Churches*, describes it as being constructed of 'homely red brick', and certainly the modest exterior gives little indication of the wonderful interior, which was remodelled extensively in 1874 by John Francis Bentley, best known for his work on Westminster Cathedral. Pevsner notes that 'Pugin despised the church'.

P

Pollock's Toy Museum – Quirky Cornucopia of Childhood

Although Pollock's Toy Museum has been in Fitzrovia since 1969, its story starts – in a roundabout way – in Hoxton, east London, more than a hundred years before that.

In 1851 John Redington set up a business making and selling toy theatres. These ornate miniature theatres, made of paper and cardboard, were immensely popular among the Victorian middle classes. Charles Dickens was hugely fond of them.

When Redington died in 1872 his daughter Eliza took over the business, marrying a furrier called Benjamin Pollock the following year. He continued the trade of making these theatres and the business continued trading, attracting acclaim from the likes

Above and right: Pollock's Toy Museum has been in Fitzrovia since 1969.

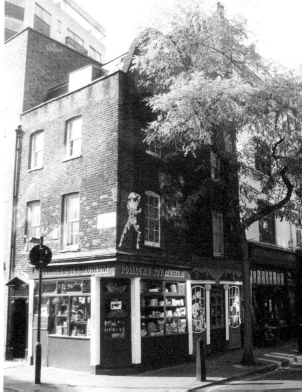

of author RL Stevenson. He wrote, 'If you love art, folly or the bright eyes of children, speed to Pollock's.'

Down the years successive generations of the Pollock family became involved, but the business was badly damaged during the blitz. A bookseller called Alan Keen came to the rescue, with a little help from the actor Ralph Richardson, relocating the business to Covent Garden. It was here, in the mid-1960s, that Marguerite Fawdry enters the story. She subsequently bought the business and started a small museum, of mainly Victorian toys, in the shop's attic.

But as the collection grew more space was needed, and in 1969 the whole operation was moved to No. 1 Scala Street, expanding shortly after and connecting with the adjoining house, just around the corner at No. 41 Whitfield Street.

The buildings date from 1767 and have been Grade II listed since 1974.

Today it is run as a private museum, overseen by Eddy Fawdry, grandson of founder Marguerite, and across six small rooms are displayed a beguiling collection of all manner of toys, from dolls and teddy bears through to soldiers and toy theatres.

The shop has been run as a separate entity since 1988 and is now located in Covent Garden.

Post Office Tower – Once Britain's Tallest Building

The GPO Tower, to give it is original name, or BT Tower as it is known today, is 191 metres in height and today dwarfed by several London structures. However, upon its completion in July 1964 it was the tallest building in the United Kingdom. It is widely known as the Post Office Tower, a name which seems to have stuck.

It was commissioned by the old General Post Office in 1961 – hence its original and most enduring name – although had first been mooted as early as 1954 as a 'radio tower'. It was eventually built as a 'telecommunications' tower. Its design, cutting edge in the early 1960s and still modernist in appearance even today, was the work of Chief Architect Eric Bedford and GR Yeats, senior architect in charge, on behalf of the Ministry of Public Buildings and Works Architect's Department.

The building was topped off on 15 July 1964, and officially opened on 8 October 1965, by Prime Minister Harold Wilson. In 1963, while Leader of the Opposition, Wilson had coined the phrase 'white heat of technological change' during a speech in Scarborough, and in 1965 the towering GPO Tower must have seemed the very embodiment of this.

From the very start it had been decided that the tower would admit members of the general public, and its doors first opened to the great unwashed on 19 May 1966, following a visit from HM the Queen two days earlier. The tower featured a viewing gallery and a shop where souvenirs could be bought. It also, famously, featured a

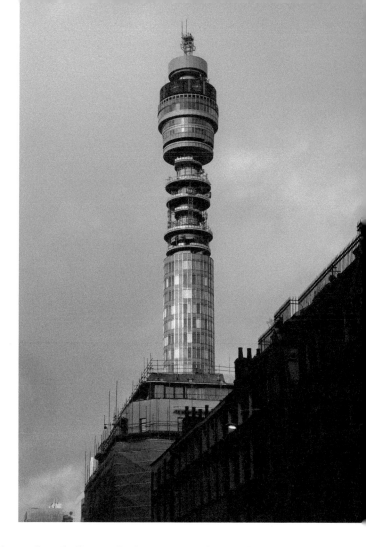

The Post Office Tower, today's BT Tower, was once Britain's tallest building.

revolving restaurant on the thirty-fourth floor, which was named Top of The Tower and run as a franchise by Butlin's. It took the restaurant twenty-three minutes to turn once through 360 degrees and popular legend has it that the uniformed waiters who would take orders would sometimes struggle to subsequently find the right table when the food was ready to serve.

In its first year of opening it attracted more than a million visitors, with an estimated 100,000 of them choosing to dine on such delights as chicken Kiev, Welsh rarebit and scampi, the latter possibly in a basket.

On 31 October 1971 a bomb left in a toilet adjacent to one of the public viewing galleries exploded. It was blamed initially on the IRA, although the Angry Brigade later claimed responsibility. Either way it marked the beginning of the end for the Tower as a public attraction. First the viewing galleries were closed, never to reopen to the paying public, and in 1980, when their franchise expired, Butlin's walked away from the restaurant.

The tower remains one of the capital's best-known landmarks and has featured frequently in films and works of fiction. It has been Grade II listed since 2003.

Quo Vadis – Karl Marx Lived Here

In Soho, restaurants come and go with a frightening regularity, but a handful of eateries have managed to go the distance. Quo Vadis, or Leoni's Quo Vadis as it has been known by generations of London diners, is chief among them.

The restaurant first opened its doors in 1926, the brainchild of Italian immigrant Peppino Leoni. He had first arrived in London in 1907 and worked extensively in the catering trade. He was first manager at Gallina's Rendezvous, a well-known Soho restaurant, and after the First World War became head waiter at the Savoy.

When Leoni opened Quo Vadis, thanks to an £800 bank loan, the restaurant was based at No. 27 Dean Street, with just seven tables, but today occupies Nos 26-29. Upon opening, the restaurant soon became popular with stars of the West End stage and gained itself a reputation as one of London's go-to dining locations.

This popularity allowed it to expand into the neighbouring premises, although Leoni's work ethic also played a large part in this success. Daniel Farson, in *Soho in the Fifties*, writes that Leoni worked a fifteen-hour day that would typically involve a 5 a.m. trip to Smithfield for meat followed by a visit to Covent Garden for fruit and veg.

When Italy declared war on Britain in June 1940 Churchill ordered that all Italian men between the ages of sixteen and seventy were interned and Leoni promptly spent most of the Second World War on the Isle of Man. When he returned to Soho he found his Dean Street premises badly damaged, or tuned into an Indian restaurant according to Judith Summers in her book *Soho*. Either way the tireless Leoni rebuilt the restaurant's reputation and business.

The buildings that house Quo Vadis are among Soho's oldest. Nos 26–28 date from 1734 and are Grade I listed, while No. 29 is a little earlier.

In addition to housing one of London's most famous restaurants, No. 28 was also home to Karl Marx. The 'social, economic and political theorist', and his long-suffering family, lived in two small rooms at the top of the building between 1851–56. Conditions were so squalid – Marx himself described is as an 'old hovel' – that two of his children died while the family were in situ.

When a blue plaque was erected in 1967 in memory of Marx, Leoni was not best pleased, declaring, 'My clientele is the very best ... nobility and royalty, and Marx was the person who wanted to get rid of them all!' The plaque is still there today.

In 1990 Quo Vadis was taken over by the perhaps unlikely partnership of 'superchef' Marco Pierre White and artist Damien Hirst, with the name changed to Leoni's Quo Vadis Marx, which doesn't really roll off the tongue. The partnership didn't last.

R

Raymond Revuebar – Strip Venue Synonymous with Soho

From first opening in 1958, until its eventual closure forty-six years later, the Raymond Revuebar was a Soho landmark, a spectacular explosion of neon, burlesque and good old-fashioned British striptease that became synonymous with London's naughty square mile.

Based in Walker's Court, an alley linking Brewer Street with Berwick Street, the club was the brainchild of Liverpool-born Paul Raymond, who had cut his theatrical teeth schlepping around the provinces with a number of nude revue shows. Deciding to set up a cabaret-style strip venue in London, he spent a year and a half looking for suitable premises before discovering the Doric Rooms, a dining room and meeting space that was up for grabs.

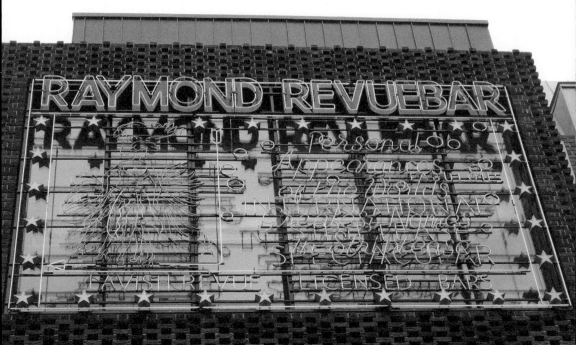

Right and opposite: Although now closed, Raymond Revuebar has left its mark on Walker's Court.

In its early days the Raymond Revuebar offered a traditional, if perhaps a little saucy, range of exotic dancing. It also enjoyed a spell in the limelight as a 'must visit' club, attracting a number of celebrities of the day.

But by later turning itself into a members' club, the Revuebar was one of the only venues in London able to offer full-frontal nudity at a time when the Lord Chamberlain's Office banned models from any kind of movement on stage, something that would change with the 1968 Theatres Act. After this piece of legislation, which allowed much more freedom, and in some cases left very little to the imagination, the Revuebar's offering turned into a constantly changing procession of spectacular and sizeable erotic productions. Not for nothing did the club proclaim itself 'The World Centre of Erotic Entertainment'.

The success of the Revuebar enabled Raymond to expand his operations in Soho and his business empire soon grew to include several other venues, a stable of lucrative soft porn magazines and a property portfolio that helped him amass a sizeable fortune. *The Sunday Times*, in 2004, estimated his fortune at £600 million and he featured in the newspaper's annual Rich List. However, one estimate, ten years earlier, estimated

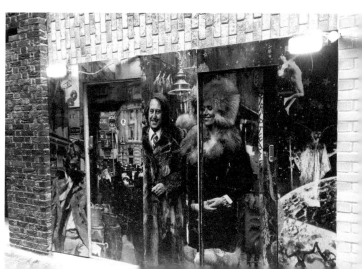

Paul Raymond depicted on a hoarding during redevelopment work at Walker's Court.

his wealth at £1.5 billion, which if true would have made him 'Britain's wealthiest man', ahead of the Duke of Westminster.

The wall of neon in Brewer Street that advertised Raymond's Revuebar has become iconic over the years and Raymond, nicknamed the King of Soho by some and the Mr Clean of porn by others, was widely regarded as the acceptable and legitimate face of the business of sex in Soho. But times changed, and the Revuebar was increasingly being regarded as old fashioned and old school.

In 2004 it closed its doors in the face of a competitive and changing environment. The venue itself has had several different incarnations since, and the Walker's Court area (like much of Soho) recently underwent a major redevelopment.

Raymond died in 2008.

Ronnie Scott's – Legendary Jazz Club

Soho's once vibrant live music scene isn't what it used to be, but thankfully Ronnie Scott's club in Frith Street continues to fly the flag, and more than sixty years after first opening remains one of the best-known jazz venues in the world.

The club opened its doors for the first time on the evening of 30 October 1959, located in a tiny basement at No. 39 Gerrard Street. Back then Gerrard Street was just another down-at-heel Soho thoroughfare; today it marks the spiritual and geographic centre of London's Chinatown. The bill on that opening night was topped by the Tubby Hayes Quartet.

The men behind the club were saxophonist Ronnie Scott, after whom the club was named, and his business partner, and another gifted musician, Peter 'Pete' King. The two men, both East End born and bred, had played together in a variety of bands from the early 1950s onwards. It was thanks to a loan of £1,000 pounds from Scott's stepfather that they were able to bankroll the club at all.

Although these days Scott, who died in 1996, is best known for his association with the club that bears his name, he was a talented and respected musician in his own right and very much at the forefront of the English post-war jazz boom. In 1957 he travelled to New York, leading his own sextet, at a time when very few British players were deemed good enough to play for American audiences. Scott, incidentally, played tenor sax on The Beatles' 1968 hit *Lady Madonna*.

Ronnie Scott's soon established itself as the capital's premier live jazz venue, and, once a Musicians' Union-inspired ban on overseas players had been lifted, its reputation was good enough to attract a number of influential international performers, starting with a four-week residency by Zoot Sims in 1961.

In 1965 the club moved to its current location at No. 47 Frith Street. Since the move across Shaftesbury Avenue, some of the most influential names in jazz have taken to the club's intimate stage. They include, to name just a few, Sarah Vaughn, Miles Davis, Chet Baker, Ella Fitzgerald, Nina Simone and Count Basie, in addition to Wynton Marsalis and the band Weather Report.

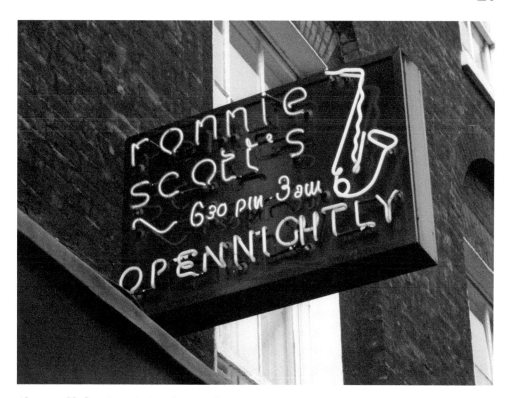

Above and below: Ronnie Scott's is a Soho institution.

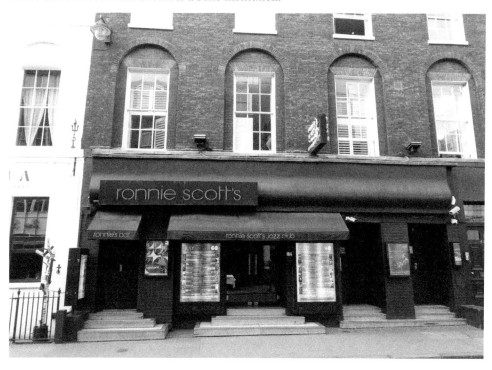

Away from jazz, the likes of Tom Waits, Jack Bruce and the Notting Hillbillies, featuring Mark Knopfler, have also performed here. In May, 1969, The Who performed their rock opera *Tommy* live here for the first time, deafening the assembled members of the press in attendance.

It was at Ronnie Scott's club, little more than a year later on the evening of 16 September 1970, that Jimi Hendrix played guitar in front of an audience for the final time. He had been persuaded to join ex-Animals singer Eric Burdon and the band War on stage and played on two songs, *Tobacco Road* and *Mother Earth*, before an impromptu group jam. By all accounts Hendrix was on fine form. Two days later he was dead.

Following Scott's death, King continued to manage the club for a further nine years before eventually selling it as a going concern to the partnership of theatre impresario Sally Greene, who had known the club since her teens, and the philanthropist Michael Watt. King passed away in 2009.

The club continues to thrive.

St Patrick's – Catholic Church in the Heart of Soho

It comes as no surprise, given how historically cosmopolitan Soho's population has been over many years, that the area has many varied places of worship.

St Patrick's is the area's best-known Catholic church and dominates the eastern side of Soho Square. Although the majority of early immigrants to settle in Soho and the adjoining districts were French Protestant Huguenots, sizeable Irish and Italian communities also developed and when Carlisle House was demolished in 1791 a modest building to the rear – 'once the music-room of Lord Carlisle's mansion' according to Walter Thornbury in 1878's *Old and New London* – was left standing, opening in 1792 as a small chapel, catering mainly to the poor Irish immigrants who had colonised the neighbouring St Giles area. The chapel was accessed via Sutton Street, today's Sutton Row.

Behind the chapel were a group of wealthy Catholics who proclaimed themselves rather grandly as the Confraternity of St Patrick's. One manuscript, from the church's own archive, records that 'a very numerous and respectable body of Catholics conceived the wise and charitable project of establishing a Catholic Chapel'.

The current St Patrick's dates from 1893.

A number of private Catholic chapels did operate in Soho, often attached to embassies. Thornbury, again writing in 1878, mentions such a place at No. 13 Soho Square, 'the house of the Neapolitan ambassador', while the Bavarian Chapel, attached to the Bavarian embassy, could be found near Golden Square. St Patrick's, however, was open to all.

St Patrick's was demolished in 1891, almost a hundred years to the day since its inception, and in 1893 on the same site the current, rather fine, church opened its doors. It was designed by John Kelly, of the company Kelly and Birchall, and is Italianate in style – 'simplified Renaissance' according to Pevsner – and constructed of red brick. Pevsner also noted its 'Impressive interior, very Italian'.

The church closed for renovation over most of 2010 and five months of 2011. The building is now Grade II listed, but we are lucky to have it all. On the night of 19 November 1940, a German bomb penetrated the church's roof and landed in the nave. It did not go off.

Snow, John – The Pump Don't Work' Cause the Doctor Took the Handle

Considering Soho was once thought of as a rural retreat, the area developed so rapidly in the early nineteenth century that by the 1840s much of its population lived in overcrowded slums with dismal sanitation.

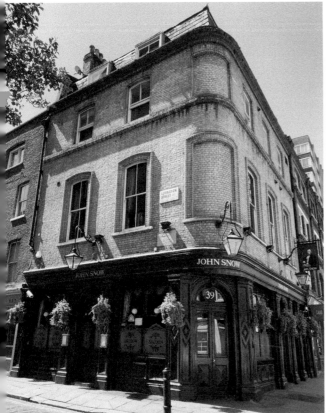

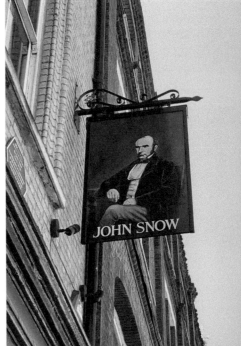

Left and below: Dr John Snow is remembered by this Broadwick Street pub.

Asiatic cholera first broke out in England in the 1830s, thriving in poor urban areas. Soho was not immune, although when an epidemic broke out in London in the summer of 1854 the area seemed – unlike Lambeth and Southwark across the Thames – to have largely escaped, with only a handful of cases reported.

However this all changed on 31 August when the first signs of what was to come appeared, notably in the Broad Street area. Broad Street is today Broadwick Street.

By 3 September, 127 people living in the area had died and by the end of the week Broad Street had become deserted, shops closed and boarded up, and those who could escape the area gone. By 10 September the death toll had reached 500 and would go on to pass the 700 mark with very few households in the area untouched by the disease.

On hand to witness the epidemic unfold was Dr John Snow. Although born in York in 1813, Snow knew Soho very well. He had arrived in London aged twenty-three in 1836 to study at the Hunterian Medical School, taking rooms in Bateman's Buildings, near Soho Square. Once he had qualified as a doctor he moved to Frith Street, although by 1854 had relocated once again, this time to Sackville Street in decidedly upmarket Mayfair.

The general medical consensus at the time was that cholera was caused by miasma – particles in the air arising from decomposing matter. However, Snow was convinced that the disease was waterborne. His research into the Soho outbreak established that most deaths had occurred near a public water pump that stood in Broad Street. Furthermore, there were hardly any outbreaks among more than 500 people in the nearby Poland Street workhouse, which had its own well, or among the seventy-odd employees at the Lion Brewery just yards from the pump, for here all employees were given a daily ration of beer and so did not drink water.

Although there was much opposition to Snow's theory, he was persuasive enough to eventually get the local vestry commission to take the pump out of action. Some versions of the story claim Snow removed the handle himself, but either way the results were astonishing and new cases of cholera all but disappeared.

Snow himself died just four years later, aged just forty-five. For most of his life he was an avowed teetotaller, although he took to drinking wine later in life once his health began to fail. In 1956 a pub near the pump, which had traded for many years as the Newcastle-upon-Tyne, was renamed in his honour.

Soho Square – Home to London's First Department Store

The development of Soho Square, on an area formerly known as Soho Fields, began in the early 1680s. It was first known as King's Square after Gregory King, who designed it for a local builder called Richard Frith, who had acquired the lease to build here. It was always intended to be an exclusive address in what was at the time a fast-developing

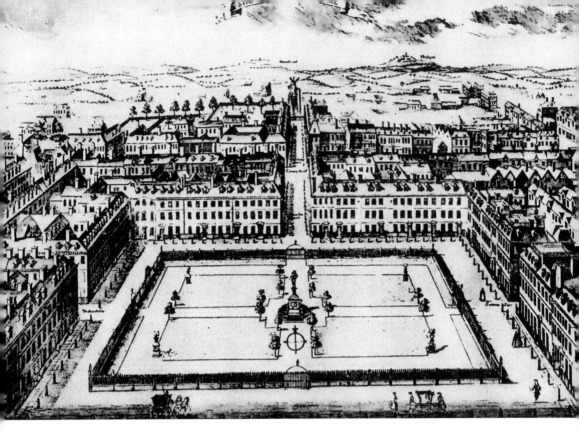

Above and left: Soho Square in the late 1600s and in 1920.

parish, and one early resident was the Duke of Monmouth, illegitimate son of Charles II. As the square grew in popularity, grand properties such as Carlisle House, Fauconberg House and Monmouth House were built.

The gardens in the middle of the square were lavish in their early design, featuring in the centre a statue of Charles II by the sculptor Caius Gabriel Cibber. This statue stood in the square until its removal in 1875. It was returned to the square in 1938,

although was not relocated in its original position. During its years away from Soho it stood in the gardens of Grim's Dyke, the country residence of WS Gilbert of Gilbert and Sullivan fame. The statue was returned to Soho by Gilbert's widow.

The Soho Bazaar, reckoned to be London's very first department store, opened at Nos 4–6 Soho Square in 1816, the brainchild of an army contractor by the name of John Trotter who had made his fortune during the Napoleonic Wars. It remained trading until 1885, when the building was transformed into offices.

The wealthy and the aristocratic started to leave Soho Square in the 1770s, for Mayfair was now the fashionable neighbourhood of choice. However, the square remained respectable into the 1850s, although becoming less residential as industry and commerce moved in.

The food producer Crosse and Blackwell had been at Nos 20–21 since 1839, and their operation here grew substantially over the years (they also had premises nearby in Charing Cross Road). They remained in the square until 1920. Their former premises were demolished in 1924, replaced by offices.

Into the twentieth century there were few, if any, residential buildings in the square, although the French Protestant Church and St Patrick's Catholic Church ensured it still played a big part in community life in Soho.

In 1937, Twentieth Century House, designed by Gordon Jeeves, was completed for the film company Twentieth Century Fox, and the square's film industry connections were furthered strengthened when the British Board of Film Censors, today's British Board of Film Classification, moved into No. 3.

Spirit of Soho Mural – Community Celebration of Area's History and Culture

Located in west Soho, at the convergence of Broadwick Street and Carnaby Street, the *Spirit of Soho* mural is a colourful and imaginative celebration of Soho's 'history and working life'. It was designed and overseen by community organisation the Free Form Arts Trust in collaboration with Alternative Arts, with local people playing a big role in creating the mural itself.

The idea for the mural was first discussed in 1989 with initial design work starting in October. A community workshop programme started in April 1990 and participants included pupils at Soho Parish School, women at the House of St Barnabas hostel and pensioners attending the Charles Norton Day Centre.

At the top of the mural is St Anne, and it is her flowing skirt that provides the canvas for a tableaux featuring some of the famous – and in one or two cases infamous – people to have lived and worked in Soho over the past three centuries.

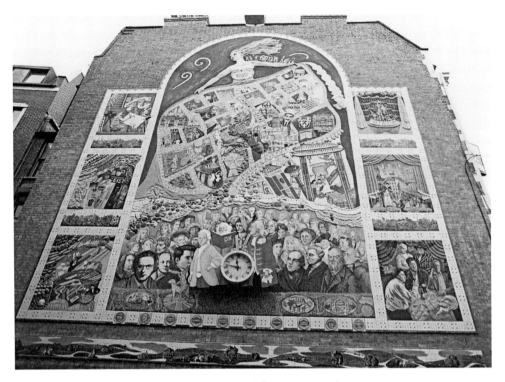

The *Spirit of Soho* mural was unveiled in 1991. (Alternative Arts)

Grouped around a central clock in the main section are William Blake, John Logie Baird, Isaac Newton, Antonio Canaletto, David Garrick and John Dryden, among others.

Then there is a young Mozart, a reflective-looking Gaston Berlemont (landlord of the French pub), French revolutionary Jean-Paul Marat and the composer George Frederick Handel.

Elsewhere Karl Marx, who laid many of the building blocks of communism, drinks a can of Coca Cola, one of the most universally identifiable symbols of capitalism, while the opera singer and 'adventuress' Theresa Cornelys rubs shoulders with Casanova. The two were briefly lovers and when the mural's clock strikes the hour Cornelys directs a sly wink in her former beau's direction.

A separate panel celebrates some of Soho's bohemians, and here you'll find the actress Jessie Matthews, writers Dylan Thomas and Brendan Behan, Low Life columnist Geoffrey Bernard and musicians George Melly and Ronnie Scott.

The mural was officially unveiled in 1991 and underwent restoration in 2006. It remains an eye-catching and colourful testament to Soho's continued cosmopolitan and bohemian nature.

Trident Studios – Ziggy Played Guitar Here

A common misconception is that the Beatles recorded everything at Abbey Road Studios, but in the later years of their career they also used a number of other studios in and around London, among them Trident Studios in Soho's St Anne's Court.

Trident was opened in 1967, the brainchild of brothers Barry and Norman Sheffield. Norman had formerly been drummer in the London instrumental band the Hunters, who had made a number of records in the early 1960s without troubling the charts.

The first record of note to be recorded at Trident was *My Name Is Jack*, a top ten hit for Manfred Mann in June 1968. Later the same year the Beatles recorded a number of sessions here. The Fab Four were increasingly unhappy with the dated technology still in place at Abbey Road, at the time a four-track set-up compared to Trident's eight-track operation. Trident was also using the noise reduction system Dolby, the first recording studio in the United Kingdom to do so.

This technology certainly struck a chord with Paul McCartney, who is quoted in John Van der Kiste's *A Beatles Miscellany* as saying, 'Words cannot describe the

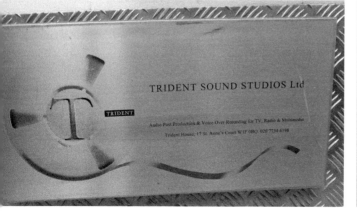
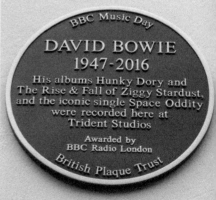

Above left and above right: David Bowie recorded his Ziggy Stardust LP at Trident Sound.

pleasure of listening back to the final mix of *Hey Jude* on four giant Tannoy speakers which dwarfed everything else in the room.'

The Beatles worked here on several occasions, recording a number of tracks that would later appear on *The White Album*, most notably *Dear Prudence, Hey Jude* and *Martha My Dear*. They would return to Trident briefly in 1969 to record part of, ironically, the *Abbey Road* album.

Certainly from this period on Trident seems to have become one of the most in-demand recording studios in the capital, attracting a list of artists that read like a who's who of rock.

John Lennon and Yoko Ono used the studio with the Plastic Ono Band and George Harrison recorded part of his masterful triple set *All Things Must Pass* here.

Queen recorded their first four albums here between 1973 and 1975, while Genesis worked here too. Elton John recorded a number of albums here, including 1973's *Goodbye Yellow Brick Road*, and Supertramp recorded their breakthrough *Crime of the Century* at Trident in 1974.

Someone who knew the studio very well was David Bowie. He had worked at Trident on a number of occasions before; in 1972, he recorded *The Rise and Fall of Ziggy Stardust* here. It was the album that made him a superstar and it was from Trident one January night that Bowie (or rather Ziggy) and the photographer Brian Ward went for a late-night stroll.

The images from that night's photo-shoot, taken in Heddon Street just off Regent Street, would lead to one of rock music's most iconic album covers.

Trident is still a working studio, these days specialising in voiceover and film-dubbing work.

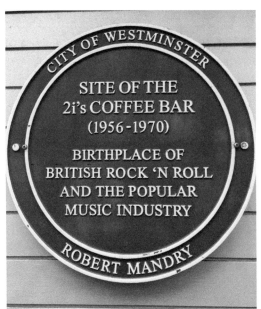

The 2I's was a hotbed of rock 'n' roll talent.

T

2I's Coffee Bar – 'Home of the Stars'

Situated at the Wardour Street end of Old Compton Street, the 2I's was a coffee and sandwich bar that from the spring of 1956, for a couple of glorious years, was a hothouse of talent in the nascent English rock and roll scene. At the address today is a green plaque declaring it 'The birthplace of British rock 'n roll and the popular music industry'.

In April 1956 Ray Hunter and Paul Lincoln, two Australian former wrestlers, took over the premises at No. 59 Old Compton Street. The building was owned by two brothers, Freddie and Sammy Irani, who provided the inspiration for the 2I's name, and from early on Hunter and Lincoln managed to tap into both the growing consumer clout of the teenager and the fad for 'frothy' coffee. They also seemed to realise that popular music, for many years the preserve of crooners and big bands, was about to explode and fragment in a completely different direction.

First they tapped into the skiffle craze, which had been propelled into the mainstream in early 1956 as Lonnie Donegan scored huge hits with *Rock Island Line* in January, followed by the double A-sided *Lost John/Stewball* in April. In July that same year The Vipers, featuring skiffle pioneer Wally Whyton, started to perform live at the 2I's and soon people were queuing around the block, which given the intimate nature of the venue proved somewhat problematic.

Whyton, quoted in John Platt's seminal *London Rock Routes*, remembered, 'The coffee bar simply couldn't contain the droves of people who wanted to see where it was all happening – after all it was only 30 feet by 10.' To ease this congestion a 2I's mark two was soon established across Shaftesbury Avenue in Gerrard Street but doesn't seem to have captured the imagination in quite the same way as the original.

Among the performers to get their big break at the 2I's was Tommy Hicks, a Bermondsey boy who had gone to sea with the merchant navy. He was spotted, performing as guest frontman with the ever-nebulous Vipers, by Hugh Mendl, A&R man at Decca Records. By the end of 1956, having adopted the stage name of Tommy Steele, the teenager from south London had enjoyed two UK hit singles and become, arguably, Britain's first pop heart-throb.

Other performers who also owe much of their success to treading the (tiny) stage at the 2I's are Cliff Richard (Harry Webb at the time), Terry Nelhams (Adam Faith) and Marty Wilde (Reg Smith). Trading on this success, the 2I's was soon proclaiming itself 'home of the stars' and also, perhaps with some justification, as 'world famous'.

The club's fortunes waned somewhat in the late 1950s, and although it would never again enjoy the same high profile, it traded until 1970.

UFO Club – Pink Floyd Were the House Band

Although it lasted little longer than a year, and took place just once a week, the UFO Club is historically regarded as the most important venue of London's 1960s underground scene.

Located in the basement of No. 32 Tottenham Court Road, beneath a cinema and in a small dance hall called the Blarney Club, it opened for the first time on the Friday evening of 23 December 1966. The men behind the club were John 'Hoppy' Hopkins and Joe Boyd, and initially it called itself UFO Presents Night Tripper, soon adopting its catchier and better-known moniker. To think of UFO as a 'club' in the conventional sense is wrong, for in addition to live music there were also poetry readings, film screenings and other happenings. John Platt, in *London's Rock Routes*, calls it 'a genuine meeting/market place for the underground', and in addition to buying 'hippy paraphernalia', a variety of mind-bending substances were also in evidence.

On the opening night Soft Machine provided the live music, with Pink Floyd providing the vibes the following week. Floyd, long before they were embraced by transatlantic superstardom, were the musical darlings of the capital's underground scene and in tandem with Soft Machine became, effectively, the house band at UFO.

Among the other bands to play at the club during its brief life were The Bonzo Dog Doo Dah Band, The Crazy World of Arthur Brown, The Graham Bond Organisation, The Move, Procol Harum (the same week that *A Whiter Shade of Pale* hit top spot in the charts) and Tomorrow, the latter featuring a young Steve Howe on guitar.

Initially UFO was declared a huge success, a 'remarkably relaxed environment', according to John Platt, one where 'Mick Jagger or John Lennon could sit all night without being pestered for autographs. But it didn't last, for as UFO's fame spread, more and more people tried to cram into what was already a compact space. Also, the original underground audience found it hard to mix with what Platt describes as 'weekend hippies', not to mention 'drunken sailors' or 'hippie-bashing skinheads'.

Things came to head in July 1967 when *The News of the World* ran a 'sex and drugs' story about the club. This proved too much for the landlord of the Blarney Stone, who asked the UFO Club to leave. The last club night at the Tottenham Court Road venue was 28 July, Pink Floyd and Fairport Convention playing live.

The club moved north to the much larger Roundhouse in Chalk Farm. However this former railway engine turning shed was just too big, lacking the atmosphere needed for a club like UFO and proving financially unviable.

The last ever UFO club night took place on 29 September 1967, with Jeff Beck headlining.

Vice – Sex and Soho

Soho has been known for its prostitutes since at least the early seventeenth century. At the time Covent Garden was the centre of London vice, but by the 1790s much of the trade had relocated the short distance to Soho. Famously, in 1758, a Mrs Goadby, inspired by several visits to France, set up her own 'Parisian' style brothel in Berwick Street, within which, according to the writer Ivan Bloch, could be found 'only the most beautiful girls ... preferably those from different countries and of different faiths'.

But it was during the twentieth century that Soho really cemented its reputation as London's best-known red-light district. During the 1930s, and at least until the outbreak of the Second World War, the area was especially known for its French prostitutes, or Fifis as they were colloquially known. These ladies, according to Judith Summers in *Soho,* could 'be recognised by their immaculate clothes ... their immaculate houses ... and sometimes by the gold chains they wore round their ankles'.

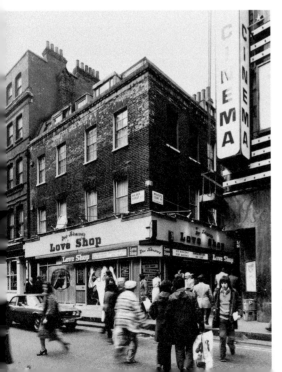

Walker's Court, 1976. (London Metropolitan Archives – City of London)

The York Minster pub in Dean Street, 'the French' as it was more commonly known, was their home from home, and under the watchful eye of pub landlord Gaston they knew they were safe from the potential hazards that they could encounter going about their day-to-day work.

There were of course also English prostitutes, but these were regarded as less refined – and less trustworthy – than the French ladies.

But whatever the nationality, during the Second World War, and in the years immediately after, prostitution in Soho was deemed to have spiralled out of control. For where there was prostitution there were pimps, and organised crime gangs. Also, while the sexual act itself was carried out behind (often fairly shabby) closed doors, much of the soliciting took place on the streets, and was often brazenly carried out.

The passing of the Street Offences Act of 1959 was intended to put an end to this, and was largely successful in driving these 'working women' indoors. The Act seems to have ushered in the age of the Soho 'walk-up', with prostitutes working in small flats and advertising the fact by placing signs in the doorway at street level, or by displaying a red illuminated sign in the window proclaiming 'Model'.

However, the Soho sex industry during the 1970s and 1980s became increasing tawdry. 'Sex' and 'dirty book' shops proliferated, as did venues offering 'live shows'.

Most infamous of all were the 'clip-joints' and 'near-beer' bars, which started in the 1960s. Not for nothing did the 1966's *The New London Spy*, in a chapter titled 'London Prostitutes', declare that 'Soho is for the real mugs.' These venues would use 'hostesses' to pry on unwary men, who with the possibility of future intimacy with said hostess

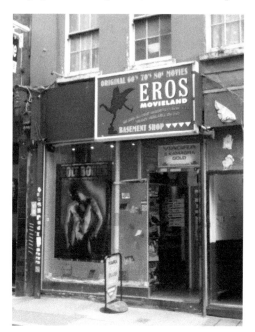 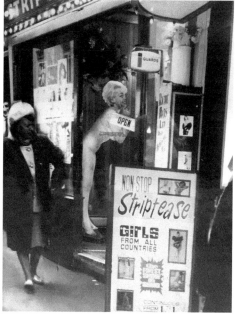

Above left and above right: The industry of sex is still visible in Soho today.

dangled before them would be encouraged to spend inordinate amounts of money on drinks. These would be non-alcoholic, for the venue would not have a licence.

There have been concerted efforts to 'clean up' Soho over the years (one anti-vice campaign in the late nineteenth century described the area as 'a perfect little paradise for pimps'), and while the sex trade and prostitution still exists in the area, it is a pale shadow of what it once was. Despite which, for many people Soho will always be London's premier red-light district.

The Vortex – Seminal Punk Venue

Although the world-famous Marquee Club never really embraced punk rock, the Vortex, located a couple of hundred yards away at No. 201 Wardour Street, certainly did.

The basement venue had previously been home to Crackers disco and the man behind its transformation into a punk club was Andy Czezowski. He had previously managed the Roxy in Covent Garden, a seminal and short-lived punk venue that had closed its doors for the last time in December 1976.

The Vortex, which had a greater capacity than the Roxy and a proper stage, opened for the first time on 4 July 1977 with a bill made up exclusively of Manchester acts, namely the Buzzcocks, the Fall and 'punk-poet' John Cooper Clarke. This was the first of the venue's Monday night events, which would become an essential weekly fix for punks.

Some of the line-ups to play at the Vortex as the summer of 1977 unfurled read, in hindsight, like a who's who of punk. On 11 July, for example, Siouxsie and the Banshees headlined, supported by the Slits and The Ants, who would evolve into Adam and the Ants.

On 1 August Generation X topped the bill, with the Lurkers and reggae band Steel Pulse also appearing. Generation X also played the following night, this time with support from Penetration. Two days later, on 4 August, X-Ray Spex headlined, the undercard featuring Eater and Wire.

As a result of the club's popularity, and also to offer a refuge to suburban punks stranded in the capital late at night, the Vortex expanded across Oxford Street and on 23 September 1977, at No. 22 Hanway Street, it opened a 'twenty-four-hour' café, comprised of a small live venue, a coffee shop and a record shop.

To mark the opening a number of bands were invited to play live and alfresco, including Sham 69, who found themselves playing on the roof of the building. Unfortunately they strayed onto the roof next door and the police were soon in attendance with Sham frontman Jimmy Pursey arrested for his troubles.

Successive changes in management at the Vortex, and a changing musical landscape, meant that into 1978 the club was struggling. The last listed concert at the Wardour Street site was 3 April, when Tubeway Army were scheduled to headline.

Although not regarded as highly as the Roxy, the Vortex was nonetheless an important venue in the history of punk. Its lasting testament is a live album, *Live at the Vortex*, originally released in 1977.

W

The Wheatsheaf – Where Dylan Met Caitlin

The Fitzroy Tavern remains Fitzrovia's best-known pub, but the Wheatsheaf in nearby Rathbone Place certainly deserves to be mentioned in dispatches. For a period in the 1940s and 1950s this was one of the most popular watering holes on Soho's bohemian trail (the area was then known as North Soho). Indeed, once the Fitzroy fell victim to its own reputation – more of a human zoo than a genuine pub – the Wheatsheaf was the premier hang-out north of Oxford Street for a host of writers, artists and various ne'er-do-wells.

Below and right: The Wheatsheaf, Rathbone Place.

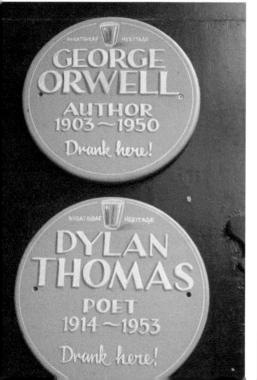

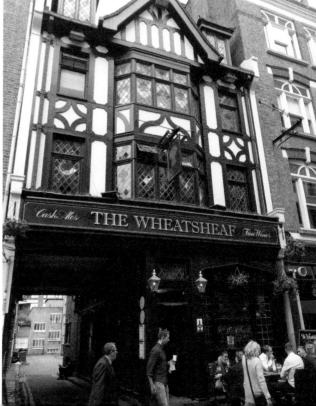

There are records of the Wheatsheaf on this site dating back to 1813, although the current building dates from 1931, overseen by John T. Quilter. With its mock-Tudor frontage and stained-glass windows, it is a good example of interwar pub design.

It seems to have attracted a bohemian clientele both before and after the Second World War, among them the writers George Orwell and Julian Maclaren-Ross, in addition to a number of faces better remembered for inhabiting the York Minster (French pub) and other hostelries just across Oxford Street.

The pub was also a regular haunt of Dylan Thomas, and it was while on a drinking spree in 1936 that he first met Caitlin Macnamara. At the time she was in a relationship with the artist Augustus John, but she and Thomas seem to have been attracted to each other from the off. The two married in 1937, and although this marriage was a stormy affair, fuelled by strong drink and punctuated by infidelities on both sides, they remained together until Thomas's untimely death in New York in 1953. He was thirty-nine.

International Dylan Thomas Day, which takes place on 14 May, is to this day celebrated enthusiastically at the pub.

One thing which attracted many was that the Wheatsheaf was one of the few pubs in London to sell Younger's Scotch Ale, which was famously stronger than most English beer available at the time. Today the pub remains relatively unchanged, although I can't guarantee you'll stumble across any drunken poets.

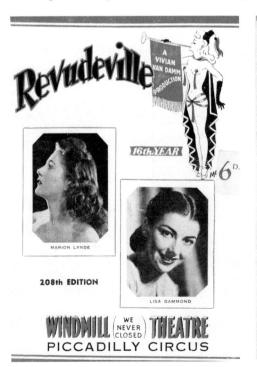 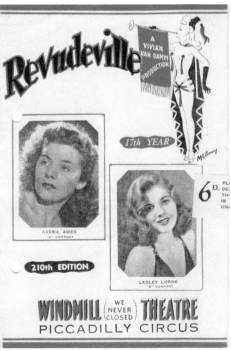

Above left and above right: Revudeville programmes from 1948 and 1949.

Windmill Theatre – 'If You Move, It's Rude'

First opening in 1909 as the Palais de Luxe, one of London's first purpose-built cinemas, and renamed the Windmill Theatre in the early 1930s, this venue became one of London's most popular live attractions and went on to be known around the world.

As a business the Palais de Luxe was never a success and hobbled through the silent film era. In 1930 the building was acquired by Laura Henderson, a wealthy widow. She hired the architect F. Edward Jones to reconfigure the interior, converting it into a 320-seat two-tier theatre, at which point it was renamed the Windmill Theatre after Great Windmill Street in which it stands.

It opened in June 1931 as a conventional theatre staging conventional theatre productions, but as a venue remained unprofitable. Henderson's masterstroke seems to have been hiring Vivian Van Damm, who she installed as her general manager. He, so legend has it, had seen both the Folie Bergere and Moulin Rouge while in Paris and upon his return promptly set about recreating an equally risqué stage show in London, one which soon had the punters queuing around the block and earning itself the nickname Revudeville.

Each day the theatre opened from 2.30 p.m. through to 11 p.m. and the entertainment was continuous, a series of tableaux vivants based on historical scenes. The appeal for much of the almost exclusively male audience was that not only was the cast all female, but most of them were nude, or at the very least semi-nude. This nudity would normally have been objected to by the Lord Chamberlain's Office, who acted as de facto censors for all stage productions in England at the time. But Van Damm and his Windmill Girls got around this problem by making sure the girls never actually moved while on stage, adopting motionless poses that emulated classical statues and, hence, could surely not be regarded as bad taste.

Another wheeze dreamed up by Van Damm was for the actual performer to remain motionless, while objects instead were moved around the performer. Van Damm's dictum, as such, was, 'If you move, it's rude.'

With the crowds flocking to see the Windmill Girls, the venture was soon wildly successful. The Windmill Theatre was the only theatre in central London to remain open throughout the German bombing raids of the Second World War (there were shelters below the theatre). The theatre was so proud of this that they coined the phrase, 'We Never Closed.' Some wags later suggested this should perhaps have read, 'We Never Clothed.'

Van Damm died in 1960 and the Windmill Girls limped on for a few years under the leadership of his daughter Sheila. But times had changed, and Soho had certainly changed, and in 1964 the Revudevile ceased. The theatre itself has seen a variety of uses since, including television studio, a venue for 'nude entertainment' and a table dancing club.

X-rated – Censorship, Certification and Sex Films

Soho, especially Wardour Street, has long been the home of the British film industry, spiritually more than physically these days. So, it seems only logical that the British Board of Film Classification, the body that certificates film and video releases in this country, should be based here too.

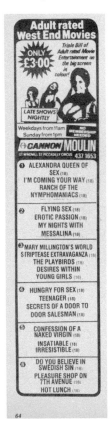

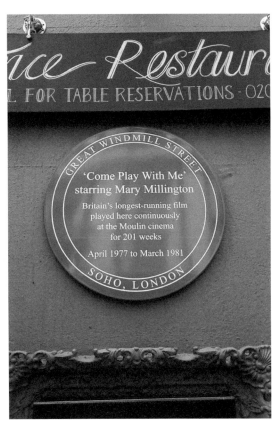

Far left and left: Magazine ad for the Moulin from 1988, and a plaque marking a London cinema milestone.

Formed in 1912 as the British Board of Film Censors, a collective effort by the film industry of the day, the organisation was initially based at Nos 133–135 Oxford Street, on the corner with Wardour Street. It later relocated to Wardour Street and has for many years been based at No. 3 Soho Square. Its aim, at a time when individual local authorities had statutory powers over film releases, was to bring some consistency to the table. Interestingly, statutory powers over film releases still remain ultimately with local councils.

Initially there were just two film classifications: 'U' for universal viewing and 'A', which was deemed 'more suitable for adults'. These evolved in the preceding years with several other degrees of classification added along the way. 'H', for instance, was added in 1932 to deal with the glut of horror films that were emerging at the time, and in 1951 was changed to 'X', which meant the film in question was deemed unsuitable for anyone under the age of sixteen.

Much later down the line, 'AA' ('admission to children of fourteen years and over') was introduced and the age limit for X-rated films was increased to eighteen years of age. The current UK film classifications, as of 2019, are 'U', '12A', '12', '15' and '18'. There is also the 'R18' classification, for films 'containing more explicit sexual depictions', which seems somehow apt given that Soho was also both the centre of the UK's sex film industry and the location of many cinemas that specialised in showing these films.

For a while there were a number of private members-only film clubs – and no doubt many an illegal basement venue showing equally illegal films. There were also a number of mainstream cinemas showing adult movies, among them the Astral in Brewer Street and the Moulin in Great Windmill Street.

The Astral started life in June 1973 as the Oscar, featuring two screens that could seat 150 and 140, respectively. It was renamed the Focus less than a year later, but in July 1974 became the Astral, when it started showing 'soft core' sex films.

The Moulin was one of Soho's very first cinemas, opening as the Piccadilly Cinematograph in March 1910. Initially it had only one screen, with a capacity of 300.

In the 1930s it became the Piccadilly News Theatre and, post-war, the Cameo. It was refurbished in the early 1960s and renamed the Cameo Moulin, which was later shortened. At this point in its history it turned to adult films. Mark Edmonds, in 1988's *Inside Soho*, described it as 'Sleazier than the Astral', and an ad of the same year, in weekly listings magazine *What's on In London*, informs us that among the films showing were *Secrets of a Door-to-Door Salesman* and *Mary Millington's World Striptease Extravaganza*.

The advent of video and later DVD, alongside Soho's changing demographic, spelt the end for both cinemas. The Moulin closed in 1990, and the Astral struggled on until 2004.

York Minster – Now the French House, Officially

If there is one pub that defines the true bohemian spirit of Soho it is the French House in Dean Street, or the York Minster to give it its name pre-1984.

Originally a wine shop, recorded here in 1831, it adopted the York Minster name on account that it stood on what was once church property. By the 1890s the Anglo-German Schmitt family were landlords and when Christian Schmitt died in 1911 his wife, Bertha, took over. However, when the First World War started in the summer of 1914 things became rather difficult for anyone even vaguely Germanic and Bertha soon sold the pub to Victor Berlemont, a Belgian.

Soon after the Berlemont family moved into the York Minster, a son was born in a room above the bar. Named Gaston, he took over the running of the pub upon his father's death in 1951 and over the proceeding forty-seven years would become possibly the best-known pub landlord in the country, and also one of Soho's truly legendary characters.

Although of Belgian descent, Gaston was a true son of Soho, growing up in the pub and going to school locally. Most who encountered him wrongly assumed he was as French as Ricard, but with the Gallic influence in Soho still great in the years before 1939 Gaston was happy to make the most of this. His pub had always attracted a strong French clientele, and after the fall of France early in the Second World War this intensified.

The York Minster was a popular meeting place for the Free French Forces, and certainly General Charles de Gaulle would have sipped the occasional glass of Pernod here. It has been suggested that he wrote his famous *A tous le Francais* speech in the pub.

It was this French connection that earned the pub its nickname. It was widely known as the French pub, or more commonly as just 'the French'. When the real York Minster caught fire in 1984 contributions towards the cathedral's restoration apparently started to arrive at the Dean Street pub. When Gaston forwarded these

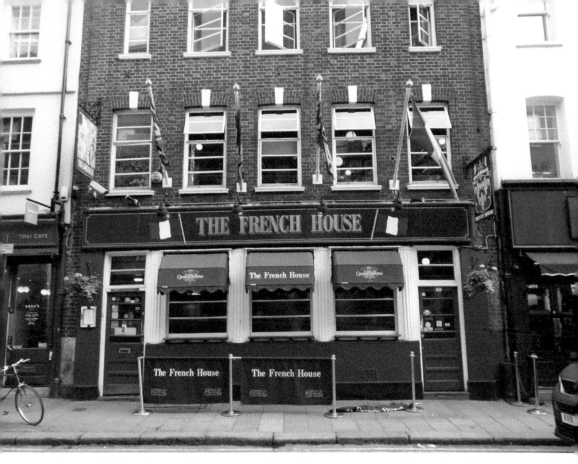

Above and below: The French House, once the York Minster, remains distinctly Gallic.

donations to York, he discovered that they had been receiving his deliveries of claret. To help avoid any further confusion the pub changed its name, officially, to the French House.

Perhaps the pub's golden age was during the 1950s when it became one of the main watering holes for the bohemian set of artists, writers and hangers-on who made Fitzrovia and Soho their stomping ground. Francis Bacon, Lucian Freud, Malcolm Lowry and Augustus John were all regulars and Dylan Thomas, perhaps in his cups, once left the original manuscript of *Under Milk Wood* behind him in the pub. Thankfully it came to no harm.

Gaston retired on Bastille Day 1989, declaring, 'After 75 years here, I don't know whether to be sad or relieved.' He died the following year. The pub remains defiantly eccentric and distinctly Gallic.

Z

Zevon, Warren – Werewolves of London

Although there are many, many songs that namecheck Soho, few are as endearingly strange and infectious as Warren Zevon's *Werewolves of London*.

Zevon was a remarkable singer-songwriter who, despite much critical acclaim and the admiration of many top musicians, never achieved the commercial success he deserved. *Werewolves of London*, which was released as a single in 1978, gave him his biggest hit, reaching No. 21 on the Billboard Hot 100 US singles chart.

Among the musicians playing on it are Mick Fleetwood and John McVie, both from Fleetwood Mac. It was produced by Jackson Browne, who was something of a mentor to Zevon.

Prior to becoming a solo artist in his own right, Zevon had been a jobbing musician and spent several years touring as keyboard player with the Everly Brothers. It was Phil Everly who challenged Zevon to write a song that shared its title with the 1935 film *Werewolf of London*. When Zevon did rise to this rather odd challenge, and working alongside LeRoy Marinell and Waddy Wachtel, the song apparently took around fifteen minutes to write, although was rather more challenging when it came to recording.

While it has a memorable melody, it's the lyrics that really intrigue. Especially as it was written in sunny Los Angeles by a group of US musicians. There is mention of Mayfair and also the county of Kent, but most memorable of all is the opening verse which tells of a werewolf, with a Chinese menu in his hand please note, walking in Soho. And the destination of our hairy friend? He's off to Lee Ho Fook, of course, and beef chow mein is on the menu.

Lee Ho Fook is a restaurant in Garrard Street, the main thoroughfare of London's Chinatown. The capital's first sizeable Chinese community grew around the Limehouse area, a direct result of close proximity of the Thames and its waterborne trade. When this went into decline much of the Chinese presence headed west, settling in and around Gerrard Street from the 1950s onwards.

But with many, many restaurants to eat at in this part of town, how come Lee Ho Fook had the honour or popping up in the song? Certainly Zevon visited London on many occasions; the earliest I can trace being the winter of 1976 when he toured the

UK as support act for Browne. Perhaps during this visit he sampled the beef chow mein in question?

Certainly the restaurant makes the most of being immortalised in popular song, and a poster of Zevon can be seen in the window. Zevon, who once described *Werewolves* as a 'dumb song for smart people', died in 2003. I met him once. He was a very funny man.

Bibliography

Bailey, Nick, *Fitzrovia* (New Barnet: Historical Press, 1981)

Brown, Mick, *London Brewed* (Longfield: Brewery History Society, 2015)

Burke, Thomas, *Nights in* Town (London: George Allen & Unwin, 1918)

Edmonds, Mark, *Inside Soho* (London: Robert Nicholson, 1988)

Farson, Daniel, *Soho in the Fifties* (London: Michael Joseph, 1987)

Frame, Peter, *Rock Gazetteer of Great Britain* (London: Banyan Books, 1989)

Gilnert, Ed, *West End Chronicles* (London: Penguin, 2008)

Gimarc, George, *Punk Diary 1970-1979* (London: Vintage, 1994)

Girouard, Mark, *Victorian Pubs* (London: Yale University Press, 1984)

Hibbert, Christopher, *London's Churches* (London: Queen Anne Press, 1988)

Howse, Christopher, *Soho in the Eighties* (London: Bloomsbury, 2018)

Jenkins, Simon, *England's Thousand Best Churches* (London: Penguin, 2000)

Platt, John, *London's Rock Routes* (London: Fourth Estate, 1985)

Sarto, Darcy, *Lady Don't Fall Backwards* (Otley: Skerratt Media, 2014)

Summers, Judith, *Soho* (London: Bloomsbury, 1989)

Walford, Edward, *London Recollected, Vol III* (London: Alderman Press, 1986)

Weinreb, Ben, and Christopher Hibbert, *The London Encyclopaedia* (London: Macmillan, 1995)

Acknowledgements

I am grateful to a number of people who have helped with this book. I would like to especially thank Daniela Rosello (and Loubeeloo) who at the last moment helped with photographic duties. I would like to thank Jeff Sechiari and Ken Smith at the Brewery History Society, also Georgina Wald at Fuller's and Peter Dickinson at the Labologists Society. Thanks also to Min Shrimpton at Kettner's, Maggie at Alternative Arts and Eddy at Pollock's Toy Museum. I must also say 'Oi Oi Saveloy!' to my friends and colleagues at both Shepherd Neame and BBC Radio London for their encouragement.

Most of all I want to thank my wife Lydia and my daughter Harriet. They are my true stars. As always, *Altiora petimus*.